A–Z
OF
LICHFIELD

PLACES - PEOPLE - HISTORY

Jono Oates

AMBERLEY

Dedicated to my late parents, Freda and Michael Oates, who always supported me in everything I did.

First published 2019

Amberley Publishing
The Hill, Stroud, Gloucestershire, GL5 4EP
www.amberley-books.com

Copyright © Jono Oates, 2019

The right of Jono Oates to be identified as the Author of this work has been asserted in accordance with the Copyrights, Designs and Patents Act 1988.

ISBN 978 1 4456 9177 0 (print)
ISBN 978 1 4456 9178 7 (ebook)

British Library Cataloguing in Publication Data. A catalogue record for this book is available from the British Library.

Typesetting by Aura Technology and Software Services, India. Printed in Great Britain.

Contents

Introduction

Lichfield is in the heart of the rural county of Staffordshire and is a small cathedral city, but has a fascinating history and retains many of its historic buildings and landmarks. It is notable for its three-spired cathedral and also for being the birthplace of Samuel Johnson, the man who published the *Dictionary of the English Language* in 1755. The city was also home to Shakespearean actor David Garrick, the antiquarian Elias Ashmole (founder of the Ashmolean Museum) and Erasmus Darwin, the grandfather of Charles Darwin.

Lichfield can trace its roots back to the seventh century and it was ransacked during the English Civil War. In the eighteenth century it became known as the coaching city, a halfway stop for coaches travelling between London and the north, and the Victorians provided their architecture and economy in the nineteenth century.

Today Lichfield is a lovely and picturesque centre of tourism with quaint streets and historic buildings. Its many parks, such as Beacon Park, along with Minster and Stowe pools, provide the city its peaceful nature and depict why Lichfield is a great place to live or simply visit.

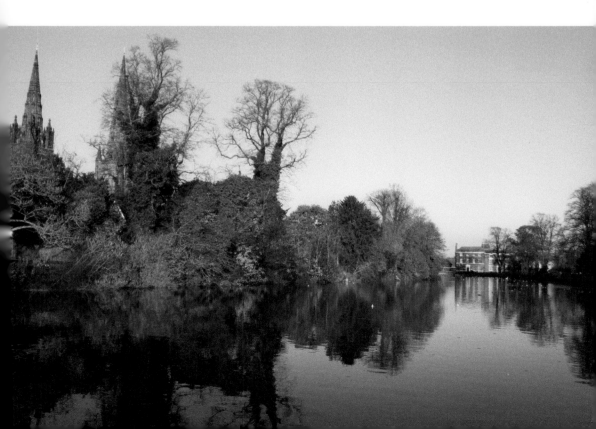

Elias Ashmole

On Breadmarket Street, two doors down from the home of Lichfield's most famous son, Dr Samuel Johnson, is the former home of Elias Ashmole. Ashmole was a seventeenth-century antiquarian, politician and alchemist who bequeathed his collection of antiquities to Oxford University, effectively creating the Ashmolean

Below left: Lichfield Cathedral.

Below right: Priests' Hall, birthplace of Elias Ashmole, Breadmarket Street.

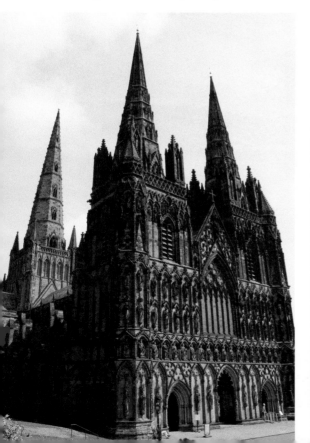

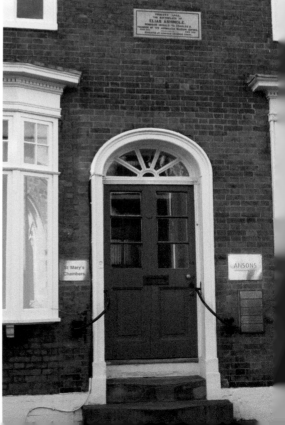

Museum. Elias was born on 23 May 1617 to his mother Anne, the daughter of a wealthy draper from Coventry, and father Simon who was a saddler. He was one of the many alumni of Lichfield Grammar School on St John Street and he was also a chorister at Lichfield Cathedral.

In 1633 Elias travelled to London where he qualified as a solicitor. When the English Civil War began in 1643 Ashmole supported the Royalist cause and served as a master-of-arms, a non-combative role. When his first wife, Eleanor, died he married Mary, Lady Mainwaring, a very wealthy widow who was twenty years older than him and who had been married three times previously. She was the daughter of Sir William Forster of Aldermaston and although the marriage was not approved of by his wife's family, it resulted in Ashmole becoming a wealthy man who could then pursue his interests in the arts without the worry of having to make a living. In 1668 Lady Mainwaring died and he remarried, this time to a younger woman, Elizabeth Dugdale who was the daughter of the antiquarian Sir William Dugdale.

Ashmole stood as a Parliamentary candidate for Lichfield in two elections, in 1678 and 1685. In the first, his agent died halfway through the campaign and he lost the election. In 1685 he did, however, attain enough votes to be elected as one of the two MPs for the Lichfield Borough constituency. But the royal court of King James II was in favour of its own candidate, Richard Leveson, and wanted him to be appointed. Ashmole was forced to stand down in favour of his rival despite the fact that Leveson had not attained the requisite number of votes through the approved voting system of the day.

In 1682 Ashmole offered the museum collection that he had built up over the years to Oxford University and the original Ashmolean Museum opened in 1683, on Broad Street in Oxford before relocating to its present location on Beaumont Street.

Elias died on 18 May 1692 at the age of seventy-six at his home in Lambeth, London. A stone plaque on the wall commemorates his former home in Lichfield, which now houses the offices of a firm of solicitors. Ashmole gifted some music manuscripts to Lichfield Cathedral and, to the city, a large silver drinking vessel that is now known as the Ashmole Cup and forms part of a collection of silverware at St Mary's Church. Two roads on the Boley Park estate in Lichfield are named after him: Ashmole Close and Elias Close.

The Court of Arraye

The Court of Arraye is a traditional, historic court that still takes place today, held on the same day as the Lichfield Greenhill Bower. The custom dates back to medieval times when each town and city had to muster its own men to protect it from attack as there was no regional army or militia at that time. The men would arm themselves with whatever weapons they had – pikes, staffs, swords or knives – and would then take part in the annual Court of Arraye where they would show their arms to prove that

they were a fighting force to be reckoned with. Today the ceremony is a light-hearted one with the petty constables, known as the dozeners, representing different areas of the city presenting their annual reports of the misdemeanours of the residents of the city that have occurred in the previous twelve months. After all the reports have been heard the Court is closed and the Officers of the Court take part in a procession that is part of the Lichfield Greenhill Bower event.

The Lichfield Angel

In 2003 excavations took place in the nave of Lichfield Cathedral to install a retractable platform on the floor of the nave. Workers unearthed part of a limestone panel featuring an angel with an upraised hand. Archaeologists believed that it formed part of a larger casket and that it may have been the burial casket containing the remains of St Chad, the first bishop of Lichfield. This further led the archaeologists to believe that the original church of St Mary's built in the eighth century by Bishop Hedda was on the same site as the current cathedral. The Lichfield Angel is now on display at the cathedral and is recognised as one of the best examples of Anglo-Saxon masonry in the country.

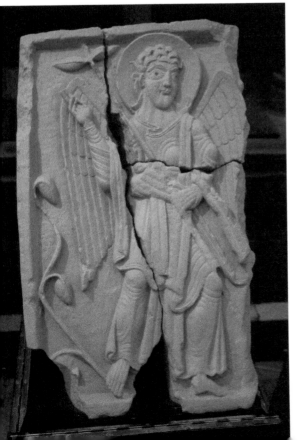

The Lichfield Angel.

The Angel Croft Hotel

The Angel Croft Hotel is, appropriately, very close to the home of the Lichfield Angel at Lichfield Cathedral, on Beacon Street. The building was originally built around 1790 for George Addams, a Lichfield wine merchant. By 1827 it was auctioned for sale at the Swan Hotel on Bird Street when it consisted of a capital mansion house, with a coach house, two stables, a variety of outbuildings, a hothouse, a greenhouse and two pine pits.

By 1900 it was the home of Lieutenant-Colonel John Gilbert and was known as Beacon House. (There were two houses of the same name in Lichfield at this time, the other one being in the grounds of Beacon Park and called both Beacon Place and Beacon House.) Gilbert had been Mayor of Lichfield and was instrumental in transferring the former home of Samuel Johnson from private to public ownership. In 1901, the Samuel Johnson Birthplace Museum was officially opened and Colonel Gilbert was presented with a casket made of oak from the Franciscan Friary buildings, as an acknowledgment of his role in the transfer. However, Gilbert died later that year and the building became the family home of Herbert Russell. Russell was a well-known solicitor in Lichfield and his wife, Mary, was Colonel Gilbert's second daughter, which perhaps explains why the Russells became the new owners. Russell owned the building up until 1930 and in 1931 it became a hotel and was called, for the first time, the Angel Croft Hotel.

In the 1930s it was not only a hotel but the landlords of the time also sold pedigree puppies and budgerigars and, in the fields behind the hotel, kept chickens that they also sold through the local newspapers.

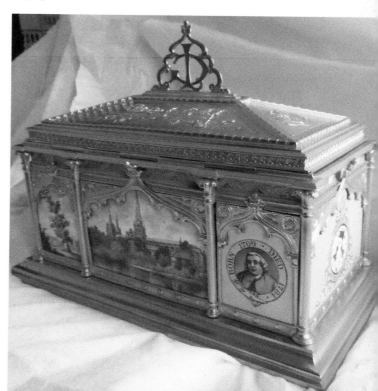

Lt-Col John Gilbert's casket.
(Photo: Samuel Johnson
Birthplace Museum)

The hotel was involved in two strange legal cases in 1939 and 1949. In 1939 Edward Jones, a gown manufacturer, and schoolteacher Eileen Haines, both from Birmingham, were charged with stealing items and money from the Parson and Clerk Hotel in Sutton Coldfield and the Angel Croft Hotel. Jones stole money and a stool from the Sutton Coldfield hotel and also stole a table, an electric reading lamp, two statuettes, two ashtrays, a bell and twelve gramophones from the Angel Croft. He explained in court that he had stolen the items as an act of bravado for a bet and that he had intended to return all the items to the hotel in due course. Jones was fined £50 and Haines £10 by the court.

In July 1949 a thief posed as a US Army soldier and attempted to steal money and belongings from the hotel staff and guests. Anthony Collins was not an American but was from Hatfield in Hertfordshire. In May 1949 he had stayed at the Angel Croft posing as a US soldier and wearing an appropriate army uniform. While at the Angel Croft he stole £38 from the owner of the hotel, Leonard John Sawyer, and a diamond watch from one of the other hotel guests, Gladys Foulkes. Collins had obtained his uniform at Brockenwood, a US Army camp in Lancashire where he had posed as a staff sergeant in the American army. At his trial Collins also admitted twelve further charges of theft, mainly from other soldiers at the army camp while he had been in disguise. Giving judgement, the court recorder said that Collins had an appalling record and that he had stolen not only from the public but also from American troops who considered him to be a comrade. Although totally disgraced, the counterfeit soldier avoided prison. He was sent instead to a Military Corrective Training Centre, a new form of detainment camp for military personnel only, which had been introduced in the early 1940s.

From the 1960s to the 2000s the Angel Croft was a very popular hotel, restaurant and nightspot but numbers declined after that and it closed as a hotel in 2008. It stood empty for some years but has now been purchased by a local company for conversion to apartments. Friel Construction Limited, of Walsall, is renovating the building while retaining many of its original features.

The former Angel Croft Hotel.

B

James Boswell

James Boswell was a friend, companion and biographer of Samuel Johnson. Born in Edinburgh, he was the son of Lord Auchinleck. He ran away from the family home to London, where he met many of the artistic social circle including, in 1763, Samuel Johnson, who by then had achieved national acclaim for the publication of his *Dictionary of the English Language.* Despite the thirty-year age difference between the two men, they became firm friends – a friendship that was to last all of their lives.

Boswell studied as a lawyer and his legal career was described as competent but uneventful. In 1773 he travelled with Johnson on a tour to the Hebrides in Scotland and Boswell recorded incidents from their journey and his conversations with Johnson into his diary. When Johnson died in 1784 Boswell wrote about his friendship, their adventures together and correspondence with his friend, starting with the *Journal of a Tour to the Hebrides* and continuing with a *Life of Johnson,* published in 1791. His biography of Johnson is said to be one of the greatest ever written in the English language.

James Boswell statue, Market Square.

Boswell died in May 1795 and a statue of him stands on Market Square in Lichfield, close to that of his friend Johnson. The statue was sculpted by Percy Fitzgerald who presented it as a gift to the city of Lichfield and it was unveiled in 1908.

Lichfield Greenhill Bower

The Lichfield Greenhill Bower is another of Lichfield's ancient traditions. The Bower dates back to medieval times and was traditionally the procession that would take place after the Court of Arraye. Having displayed their arms, the men of the city would then assemble at a covered, decorated erection known as a bower, to enjoy beef and ale. This gathering later expanded to include a walk round the streets of Lichfield to display their weapons and firepower, accompanied by Morris Dancers and covered with garlands. During the time of King James II a recognised national army was established and the Courts of Arraye and musterings of local troops became unnecessary. The vast majority died out across the country, but Lichfield decided to keep its Court of Arraye and with it the Lichfield Greenhill Bower festival. Today the procession is made up of a number of decorated tractors and vehicles accompanied by music and dancers who parade through the streets of Lichfield before finishing with a large funfair on the fields of Beacon Park.

Lichfield Greenhill Bower.

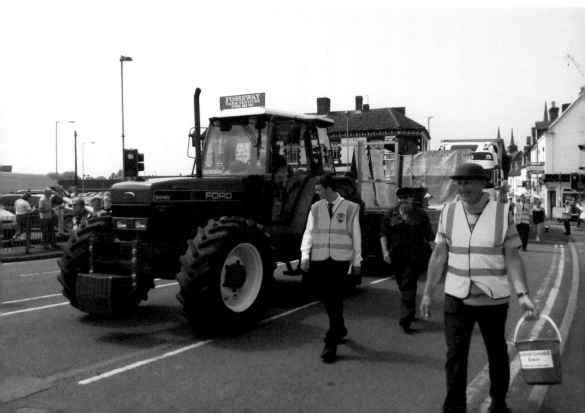

Robert Bridgeman and Sons

Robert Bridgeman and Sons was one of the most prolific producers of stonemasonry and woodcarvings of the Victorian era, producing many pieces of work not only in Lichfield but also all over the country. Robert Bridgeman had been born in Burwell, Cambridgeshire, in 1844 and trained as a stonemason at several firms in Cambridge. In 1879 he set up his own business having moved to Lichfield. Originally he had a small workshop close to Minster Pool but he later moved to larger premises in Quonians Lane off Dam Street, one of Lichfield's oldest and most quaint streets.

Bridgeman employed a team of specialist and expert stonemasons and woodcarvers to produce an extensive and impressive catalogue of work. When the west front of Lichfield Cathedral was being restored under the instruction of the architect Sir George Gilbert Scott, it was the Bridgeman workshops that produced the majority of the statues that populated the revised frontage, representing more than 100 statues of kings, biblical figures and noted people of Lichfield.

The Bridgeman workshops also produced the statue of King Edward VII that stands in Beacon Park and the statue of a sailor on the side of the old Free Library and Museum on Bird Street. However the sailor should not have been installed at Lichfield but at York! In 1905 the city of York asked Bridgeman to create eight

Robert Bridgeman and Sons, Quonians Lane.

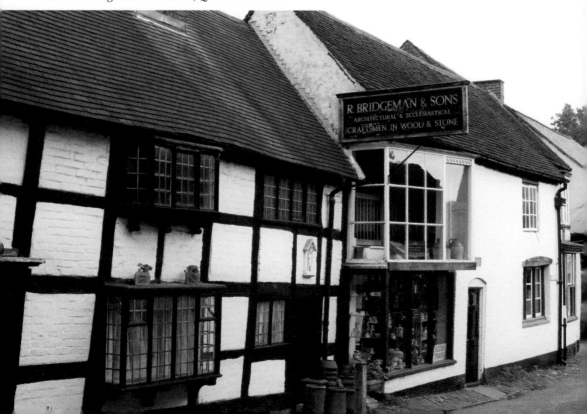

statues of representatives of all the Armed Forces, to be mounted on an octagonal monument at Duncombe Place in York as a memorial for the fallen of the South African Wars. Bridgeman created the statues, including the sailor, and they were dispatched to York. However, the authorities there were not satisfied with the statue of the sailor because the Lee-Enfield rifle he was holding was pointing outwards in what was considered to be an aggressive, warlike stance. As the monument was intended to represent the return of peace to the country, York Corporation thought it was unsuitable and so rejected it. The statue was returned to Bridgeman's who created another statue of a sailor holding a rope and not a gun, a more acceptable representation. Bridgeman now had a single statue from a set of eight and had no real use for it, so he agreed to give the statue to the Lichfield Corporation to place on the side of the Free Library and Museum where he still stands today. Unfortunately, due to damage or vandalism, the barrel of his rifle has been snapped off, so he looks less warlike than he did!

Below left: Sailor statue, the Free Library and Museum.

Below right: Former home of Robert Bridgeman, Dam Street.

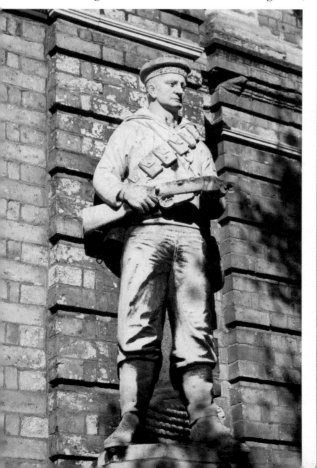

C

Lichfield Clock Tower

Lichfield Clock Tower is one of the most iconic and visible structures on the Lichfield skyline and most Lichfeldians can tell you where it is. But the tower is not on the location where it was originally built – and it almost didn't make it to its new location at all!

Built in 1863, it was originally situated on the junction of St John Street, Bore Street and Bird Street. The tower has four sides but initially there were clock faces on only three, as there were very few houses or properties on the west side of the city.

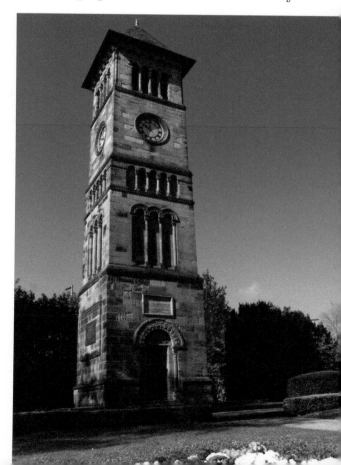

Lichfield Clock Tower.

However, one of the few residents there complained that he was unable to see the clock from his home and the fourth face was installed at a later time.

When the new Friary Road was constructed in the mid-1920s, to provide a relief road for traffic heading towards Walsall, the clock tower was in the way of the junction and the council decided that it should be demolished and removed or relocated. The council did not have sufficient funds to relocate the tower, so they invited the local people to pay for it to be moved to a new location. This generated many letters of complaint and protest meetings, as the residents were not at all happy about paying the massive amount of money needed to relocate such a substantial building. A stalemate developed as the council did not have the funds to support the relocation on their own and it looked as though the tower was going to be demolished and lost to the city forever. Fortunately a Lichfield benefactor, Sir Richard Cooper of Shenstone Court and Member of Parliament for Walsall, came to the rescue, supplying the funds that were needed to take down the tower, brick by brick, and move it to a new location on The Friary, near the Bowling Green roundabout where it still stands today. Sir Richard Cooper also funded the new Friary Road itself, an incredible act of generosity by one of Lichfield's greatest benefactors, and had it not been for his intervention the people of Lichfield would no longer be able to read the time on the famous Clock Tower.

St Chad

Lichfield's history and heritage owe much to the first bishop of Lichfield, St Chad, who came to Lichfield in AD 699, instructed to form and promote a religious settlement in the area. He came from the Northumbria region in the north-east of Britain, and was one of four brothers who were all from a religious background and who were sent to spread the word of Christianity across the country by King Wulfhere of Mercia.

Not a lot of historical, factual data exists for St Chad, although he is described in the Venerable Bede's record of the recollections of a monk called Trumbert, who mentored Bede and was himself mentored by Chad. Chad established a religious settlement close to a spring at Stowe, where there is now a church that bears his name on the far side of Stowe Pool from the cathedral. It is also said that he established a religious structure, named as St Mary's Church, and on the site of what is now Lichfield Cathedral.

Chad, with a group of seven or eight monks, set about spreading the word of Christianity through the Mercian region. He travelled everywhere by foot, refusing to travel on horseback despite the obvious benefits.

In 672 he had a visitation from a heavenly choir who informed him that he had only one week to live and that on the seventh day he would be taken to Heaven. He told his group of followers that this would be the case and, as he had foreseen, on the

Above: St Chad's Well.

Below: St Chad's Church by Stowe Pool.

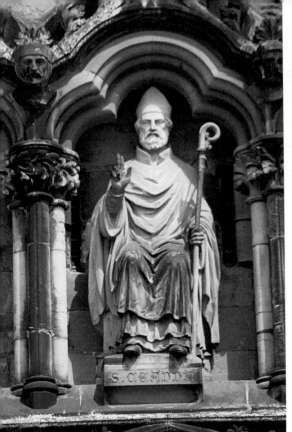
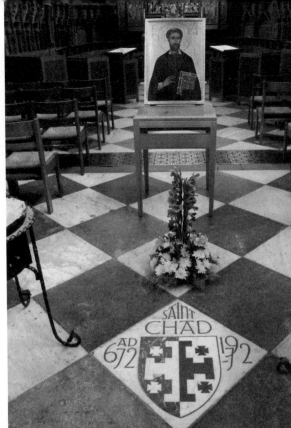

Above left: St Chad statue on Lichfield Cathedral.

Above right: St Chad's icon, Lichfield Cathedral.

seventh day following the visitation, 2 March 672, he passed away. Records show that there was a plague that swept through Britain at that time and it is likely this that took Chad's life. He became a martyr almost as soon as he had died and there are now nearly thirty churches and one cathedral dedicated to St Chad throughout the country, including St Chad's Church in Lichfield. There are two statues of St Chad at Lichfield Cathedral, one on the west front and one on the north transept. The Lichfield Cathedral School, which was formed in 1942 when it was known as St Chad's Cathedral School, has the cross of St Chad as their school emblem.

D

John Dyott

John 'Dumb' Dyott shot and killed Lord Robert Greville Brooke on 2 March 1643. During the English Civil War Lichfield was seen as strategically important and was involved in heavy fighting between the Parliamentarian and Royalist troops. Lichfield was a key city to hold due to its central location and religious importance. With no castle within the city, the Cathedral Close was the natural stronghold and it became the centre of vicious fighting and suffered severe damage as both sides wrestled for its control. In March 1643 the Royalists were barricaded in the cathedral, a deep ditch running around the perimeter formed a protective barrier on three sides, while the

Brooke House on Dam Street.

waters of Minster Pool protected the south side from attack. On 1 March 1643 Lord Brooke, a leading Parliamentarian general and an expert in relieving sieges, came to Lichfield after a successful campaign in Stratford-Upon-Avon, and on the morning of 2 March he inspected the situation at the cathedral from a location on Dam Street. As he did this he raised his helmet visor to observe the barricades and fortifications and at that moment a sniper called John 'Dumb' Dyott fired his gun at Lord Brooke from the main spire of the cathedral. The bullet struck him in the face, killing him instantly. Dyott became a hero of the Royalist cause in Lichfield as not only had he killed a key parliamentarian general but he had done so on the second day of March, which was the day that Lichfield's first bishop, St Chad, had died. The Royalists saw this as a sign that they would win the war, though, as we know, this did not turn out to be the case. The Dyott family are still based at Freeford Manor, just outside Lichfield, and there is a family vault in St Mary's Church on Market Square.

E

King Edward VII

In 1894 the Prince of Wales, later to become King Edward VII, visited Lichfield to mark the centenary of the Queen's Own Staffordshire Yeomanry Cavalry. His statue, which stands in the Museum Gardens in Beacon Park, was unveiled in 1908 by William Legge, the Earl of Dartmouth, and was sculpted by Robert Bridgeman and Sons, who were local stonemasons and woodcarvers. The firm's founder, Robert Bridgeman, gave the statue as a gift to the city. The King's Head public house on Bird Street features King Edward VII on its pub sign.

Edward VII pub sign, the King's Head.

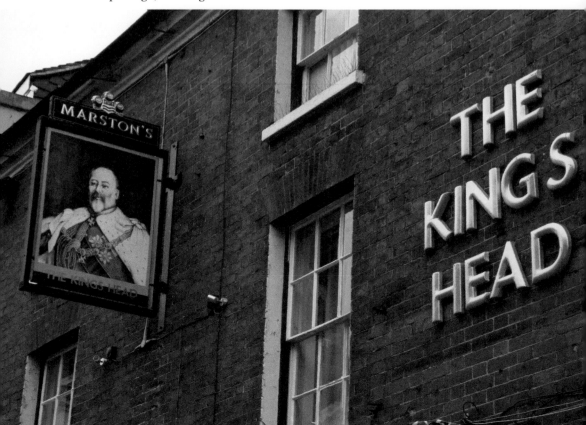

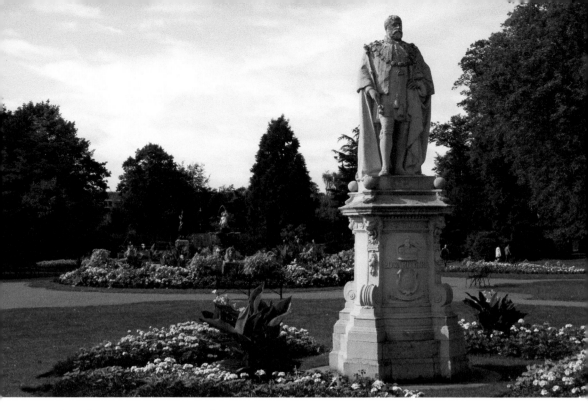

Edward VII statue, Beacon Park.

Queen Elizabeth I

Queen Elizabeth I visited the city in July 1575, following a visit to Kenilworth Castle. She stayed for a week and was entertained by a musical event at the cathedral as well as making an appearance on the market square and at the ancient Guildhall. The cost of her visit was recorded and included the payment of three pence to Gregory Ballard's maid for bringing chickens, two shillings and six pence to the keeper of Mr Raffe Boo's tent and five shillings to William Hollcroft for keeping Mad Richard quiet while the queen was there!

F

Sir John Floyer

Sir John Floyer was an English physician who was born in the village of Hints just outside Lichfield, on 3 March 1649. He studied medicine at the University of Oxford, developed a method of measuring the pulse rate of patients and was an advocate of cold-water bathing. He advised the Johnson family to take their young son Samuel to London to visit Anne, Queen of England, to see if he could be cured of scrofula.

Known as the King's Evil, scrofula was an inflammation of the glands and it was believed that if the monarch touched the inflamed area it would be cured.

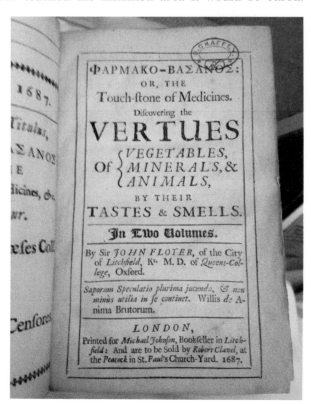

Vertues by John Floyer.
(Photo: Samuel Johnson Birthplace Museum)

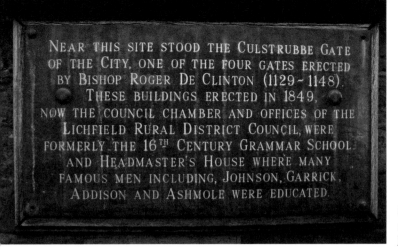

Culstrubbe Gate, on the site of former home of John Floyer.

Unsurprisingly, despite Queen Anne touching Samuel on his marked skin the disease did not heal and Johnson remained marked for the rest of his life.

Floyer was a physician in Lichfield for nearly fifty years and lived in Culstrubbe Hall on St John Street opposite St John's Hospital. The hall had been built in 1577 and after it was demolished a new building, Yeomanry House, was erected on the same site. At the same location one of the entrance gates to Lichfield from the south was known as the Culstrubbe Gate.

The Franciscan Friary

The Franciscan Friary was built in 1237 at the time of Bishop Alexander de Stavenby of Lichfield and Coventry. It was built outside the centre of Lichfield on the west side. Originally a wooden structure, it was built using trees from the forest that surrounded Lichfield at that time, from the villages of Alrewas, Whittington and Hopwas near Tamworth. As there was no natural running water at Lichfield, the Franciscan monks were supplied with water from pipes, or conduits, which transported water from a spring at the small hamlet of Aldershawe, a couple of miles away.

In 1291 a fire swept through Lichfield destroying much of the centre and the wood-built Friary. A public fund was raised to enable the building to be rebuilt, and this time as a stone structure. In 1538 the Dissolution of the Monasteries took place on the order of King Henry VIII. The Friary was destroyed and all of the fixtures and fittings were sold, with the proceeds going to the Crown. Most of the buildings including the chapel, living quarters and refectory were completely destroyed and only a handful of smaller buildings remained. In 1545 the remaining buildings were purchased by Gregory Stonynge, who developed them as a family residence. Stonynge became the first Sheriff of Lichfield in 1548 and was the Master of the Blessed Guild of St Mary in 1536. After Gregory died the house was passed to his son, and it then became a typical family residence for several centuries. In 1745 the Duke of Cumberland, son of George II, used the Friary buildings as his temporary headquarters as his troops searched the local area for Bonnie Prince Charlie of Scotland. In 1891 Mr John Toke

Godfrey-Faussett, a registrar of the Probate Court, owned the building and by 1894 a wealthy landowner from Wolverhampton, Ms Theodosia Hinckes, was the owner before it became home to the last private owner, Colonel Henry Williams. Williams sold it to Lichfield benefactor Sir Richard Cooper of Shenstone Court, but he did not intend to live at the Friary. He had purchased it so that it could be used as a community facility for the people of Lichfield. When the Girls' High School was looking to move into larger premises from its home at Yeomanry House, he transferred the building to Staffordshire County Council who allowed the school to move into the new building.

In 1933 excavations were carried out on the site of the Friary and the foundations were left exposed to display the layout of the original structures. A portico relocated from Shenstone Court, another gift from Lichfield benefactor Sir Richard Cooper to the city of Lichfield, was erected in 1937 at the entrance to the site.

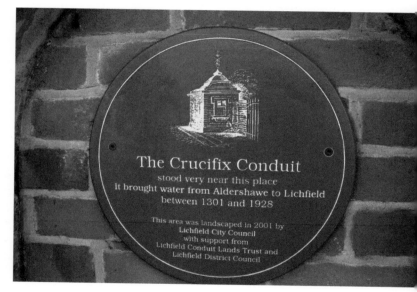

Crucifix Conduit on the site of the Franciscan Friary.

Bishop's Lodgings, Lichfield Friary.

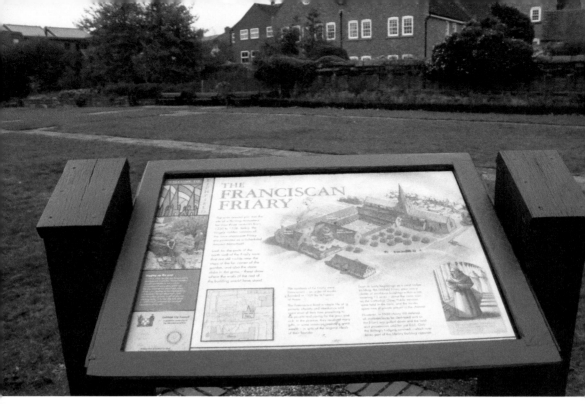

Above: Site of the Franciscan Friary.

Below: Portico from Shenstone Court, at the Franciscan Friary.

George Fox

George Fox visited the city of Lichfield in 1651. Fox was a religious dissenter in the seventeenth century who founded the Religious Society of Friends, more commonly known as the Quakers. Released from prison at Derby, where he had been jailed for his religious views, he walked with friends towards Lichfield. On spotting the three spires of the cathedral, he asked his friends what the building was and on being told that it was Lichfield Cathedral he had a vision of the streets of Lichfield being awash with blood. He then removed his shoes and walked through the city streets crying out 'Woe to the bloody city of Lichfield.' It is not known whether Fox was referring to all of the bloody deeds that had taken place in Lichfield over the years – such as burnings at the stake, hangings and other corporal punishments – or to the myth of a bloody battle that allegedly took place somewhere around Lichfield in the third century AD when a Roman Legion had wiped out a 1,000-strong Christian army, giving rise to the notion that the name Lichfield can be literally translated as 'Field of the Dead'.

The artist Robert Spence painted a scene of Fox walking through the streets of Lichfield barefoot; the painting bears the name of Fox's famous cry and is currently on display in St Mary's Church on Market Square.

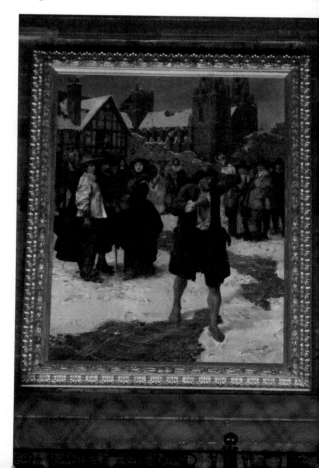

Woe to the Bloody City of Lichfield painting at St Mary's Church.

The George Hotel

The George Hotel was one of the traditional coaching inns of eighteenth-century Lichfield. Lichfield was one of the most important staging posts at this time as it was on the main road between London, the capital, and Liverpool, the port from which many ships sailed across the Atlantic to the Americas. The dramatist George Farquhar, a former recruiting officer, stayed at the George and wrote two plays there: *The Recruiting Officer* (1706) and *The Beaux' Stratagem* (1707). Some of the staff and residents of the George are featured in *The Beaux' Stratagem*, including the landlord George Boniface.

The George Hotel, Bird Street.

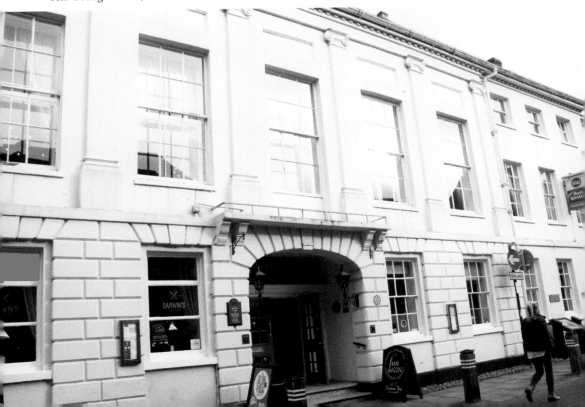

David Garrick

David Garrick was one of the foremost actors of the eighteenth century and was probably the finest Shakespearean actor of his time. His family home was on Lichfield's Beacon Street, but David was born in Hereford at the Angel Inn, where his father was on duty as a recruiting officer for the Dragoons. As a young boy he was taught by Samuel Johnson at an ill-fated, and short-lived, school at Edial, just outside Lichfield. Despite their age difference Samuel and David became friends and travelled together to London in 1737 to seek fame and fortune. Garrick had plans to be a wine merchant but instead began to act in local theatres. He achieved fame when he first took what became his most iconic role as King Richard III in Shakespeare's play. He became manager and, subsequently, owner of the Drury Lane Theatre. At his height he was the most acclaimed actor of his day, attracting the attention of King George III, who was a lover of the arts, and who came to see Garrick's performances in London.

Garrick has had two theatres named after him in Lichfield. In 1949 the David Garrick Memorial Theatre, managed by Joan and Roger Cowlishaw, opened on Bore Street. The building, which had previously been a cinema, occupied the former site of an eighteenth-century predecessor, the Theatre Royal. One of the early directors

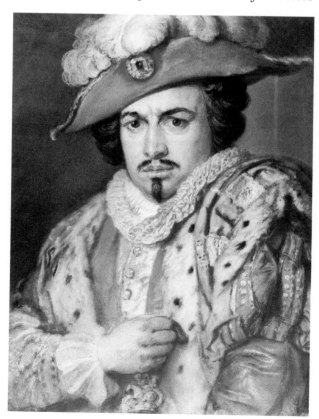

David Garrick as Richard III.
(Photo: Samuel Johnson
Birthplace Museum)

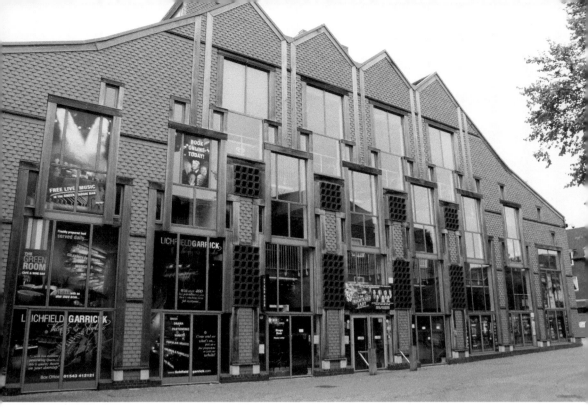

Lichfield Garrick Theatre.

of the Cowlishaws' company was Kenneth Tynan, who later became the noted, and sometimes feared, theatre critic of the *Evening Telegraph*. Hilda Braid, who starred in the television series *EastEnders*, was once a member of the company, as was Lionel Jefferies, who went on to appear with Dick Van Dyke in the 1960s film classic *Chitty Chitty Bang Bang*. After Joan Cowlishaw passed away the theatre struggled, eventually closing in 1953. The building became a cinema again and today it is the Wilko department store.

In 2004 the Garrick Theatre opened on Castle Dyke, close to the city centre and the first production staged there was *The Beaux' Stratagem*, the play that George Farquhar had written at the George Hotel. The theatre continues to host plays, drama and music events, and also a very successful traditional pantomime each Christmas.

Hall's Butchers

In the late nineteenth and early twentieth centuries there were many butchers on the streets of Lichfield and one of the most well-known was Hall's. A four-generation family business, their shop was on Conduit Street, previously known as Butcher's Row due to the number of butchers trading on the same street. Like many local businesses, the Hall family played an active role in local politics serving as local councillors and civic dignitaries. Henry Hall was sheriff in 1852 and mayor in 1863; his son James was sheriff in 1874; grandson Henry George Hall was mayor in 1918 and 1919; and great-grandson Henry James Hall was mayor in 1956, 1957 and 1970.

In 1920 Henry George Hall, former Mayor of Lichfield and a Justice of the Peace, was himself in front of the Lichfield court for breaking a licence regulation of the time. It was essential that all dogs were licensed and a police officer approached Mr Hall to ask to see the licence for his toy Pomeranian dog. Hall assured the officer that he did indeed have a licence but that it was at home. The officer accompanied Hall to his home but the licence could not be found. Hall was informed by the Local Taxation Committee that he would have to appear in court to face the charge of not having a licence, or he could choose to pay a standard fine of 15 shillings to settle out of court. He declined to pay the 15 shillings and chose to appear before the court, declaring that the cost of the

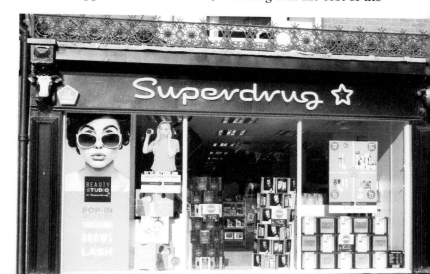

Henry Hall's the butchers, now the Superdrug store.

outofcourt settlement was far more than the cost of the licence itself. Furthermore, he felt that he was effectively being blackmailed to settle out of court in order to avoid public embarrassment. At the hearing, held at the Magistrates' Court behind the Guildhall building, it was discovered that Hall had in fact purchased the appropriate licence, but only on the day that he was stopped by the police officer! Despite this, the magistrates accepted most of what Hall had said, possibly influenced by the fact Hall was himself a JP and a noted local figure. The case was dismissed and Hall was awarded 5 shillings costs. However, two months later the county council, worried that this might set a dangerous precedent, appealed against the original decision and it was overturned. Hall was fined 5 shillings and was also ordered to pay 20 shillings in court costs.

In December 1966 Henry J. Hall announced that he intended to semi-retire. He closed the shop by Market Square, and transferred the business and its staff to No. 70 Dimbles Lane, thus ending an association with the city centre that went back to the 1830s. The shop is currently a Superdrug store but its former use can still be seen by the two bulls' heads that adorn the frontage.

Frank Halfpenny Hall

Frank Halfpenny was a Lichfield councillor during the 1940s and 1950s. He was Sheriff of Lichfield in 1938 and 1939, and Mayor of Lichfield in 1965. In 1939, at the outbreak of the Second World War, he became the first sheriff to set out on the traditional Sheriff's Ride wearing a gas mask! In 1958 he bought a former Primitive Methodist Chapel on George Lane. The chapel had been built in 1848 and was closed in 1934, reopening the following year as a hall for the Salvation Army. After he had purchased it, Halfpenny transferred ownership to the Lichfield and Tamworth Constituency Labour Party for their use. In 1984 it was transferred to the Swinfen-Broun Charitable Trust, a local charity set up to administer the monies left to the city of Lichfield by Lieutenant-Colonel Michael Swinfen-Broun of Swinfen Hall. The trust later let the hall to a local Children's Playgroup Association who still have use of it today, and is still known as Frank Halfpenny Hall.

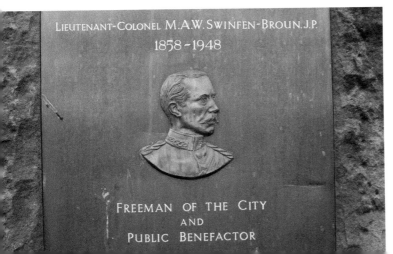

Colonel Swinfen-Broun plaque, Beacon Park.

The Swinfen-Broun clock, Donegal House.

The Herkenrode Glass

The Herkenrode stained glass in the windows of the Lady Chapel at Lichfield Cathedral is some of the most spectacular in the country and the glass is amongst the most admired. Installed in 1810, the glass was transferred from its home in Belgium and, via the canals of England, made its way to the cathedral city of Lichfield.

During the English Civil War the cathedral was used by both the Royalist and the Parliamentary forces as a defensive battleground, as Lichfield did not have a castle. The cathedral was heavily damaged by the fighting and one result was that much of the original medieval stained-glass windows was destroyed.

In 1802 a friend of the cathedral, Sir Brooke Boothby, was travelling around Europe in the wake of the Napoleonic Wars. Boothby was a friend of the polymath Erasmus Darwin and a member of the Lichfield Botanical Society Darwin formed. When his only daughter, Penelope, died at an early age Boothby entered into deep depression and took to travelling around Europe as a means of trying to relieve his dark moods. While travelling through Belgium he came upon the stained-glass windows at the dilapidated Abbey of Herkenrode, in the province of Limburg. Following the Dissolution of the Monasteries in Belgium during the late eighteenth century, the abbey had been stripped of its possessions and put up for sale. When Boothby arrived in 1802 the windows were still for sale and he purchased them for a relatively

Left: Herb Garden, Erasmus Darwin House.

Below: Herkenrode Glass crate at Gallows Wharf, Lichfield Canal Restoration.

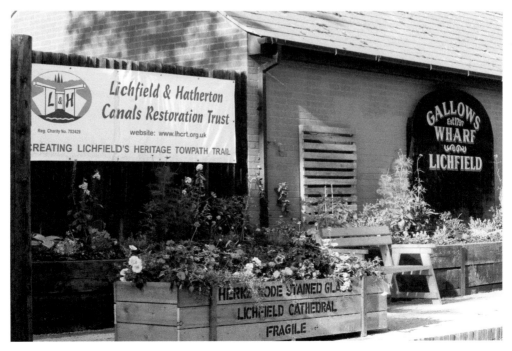

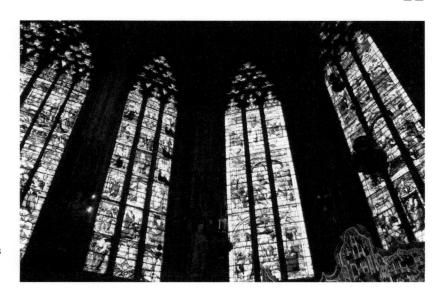

Herkenrode stained glass at Lichfield Cathedral.

small sum. The seventeen Flemish window panels had been produced in the 1530s and Boothby, an expert in sixteen-thcentury art, declared that they were amongst the finest stained glass that he had ever seen.

Boothby supervised the transfer of the panels from Belgium to England, transporting them across the sea from Rotterdam to Hull. It is believed that they were then carried to the Midlands via the extensive and widely used canal system. Of the seventeen panels that Boothby had purchased, eight were installed at St Mary's Church in Shrewsbury and the remaining nine installed at Lichfield Cathedral. It is believed that the Lichfield panels were delivered to Gallows Wharf on the Lichfield and Hatherton Canal and carried the relatively short distance to the cathedral by horse and cart. The site of Gallows Wharf has been restored by volunteers from Lichfield and Hatherton Canal Restoration Trust, and can be found close to the junction of London Road and Tamworth Road.

The Cathedral Chapter agreed to pay Boothby the cost of the window panels over a number of years. He did not profit from the exchange and the cathedral received the new panels at an excellent price. As they had been constructed for a completely different building, the panels did not fit the window areas at their new locations; additional panels and filler pieces had to be made before they could be put in place.

Because they were not a perfect fit, the panels became damaged and dirty through ingress of rain and wind, and in 2010 they were urgently in need of repair. They were removed and sent to expert restorers, during which time plain-glass panels were installed as replacements. In 2015 the fully restored and repaired Herkenrode windows were returned and HRH The Duke of Gloucester attended a special service of rededication. They are universally recognised as some of the finest Renaissance glass in the whole of the country. The Herkenrode glass, along with the Lichfield Gospels and the Lichfield Angel, form three of the great treasures of Lichfield Cathedral.

Frederic Iremonger

Frederic Aethelwold Iremonger was Dean of Lichfield Cathedral from 1939 to 1952. Born in 1878, Frederic was educated at Keble College, Oxford, and began his career as a chaplain in the East End of London. There he witnessed severe poverty among the local people, the impact of which stayed with him for the rest of his life. He had been a country curate at a number of locations, mainly in the south of the country, when he was appointed as the Director of Religion at the BBC in 1933. He was very successful in this role and was said to have improved the standard and content of religious broadcasting. In 1927 he was appointed as Honorary Chaplain to King George V, a position he held until 1936, and then as Chaplain to George VI. In 1939, at the age of sixty, he retired from his position at the BBC and returned to a role as a country curate. Later in the same year he was appointed Dean of Lichfield as successor to Dean Savage – a slightly surprising appointment, and it was felt that Frederic was never really comfortable in his new role. Despite this, Iremonger supervised the hugely successful celebration of the Cathedral's 750th anniversary in 1945, raising funds of £25,000 – a very large amount of money at that time. Iremonger served as dean until his death in September 1952, and throughout most of his tenure the Bishop of Lichfield was Edward Sydney Woods.

Opposite: Gravestone of Frederic Iremonger, Lichfield Cathedral.

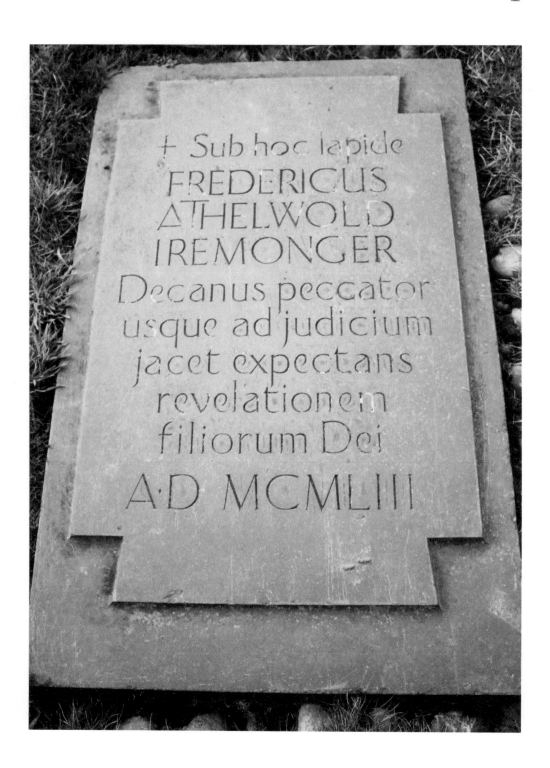

Samuel Johnson

Lichfield's most famous son is Samuel Johnson, who created a *Dictionary of the English Language*, a dictionary that was more extensive and complex than any of its predecessors. He was born on 18 September 1709 to parents Michael and Sarah in the family home on Breadmarket Street, close to the Market Square. His father was a bookseller and it is undoubtedly in his father's bookshop that the young Samuel first developed his love for words and letters.

Johnson was educated at Dame Oliver's School for young children on Dam Street, and then at Lichfield Grammar School. He started a career as a writer and journalist, but struggled to achieve success, and then briefly opened a school at Edial, just outside Lichfield – a venture that proved to be a disaster and short-lived. He travelled

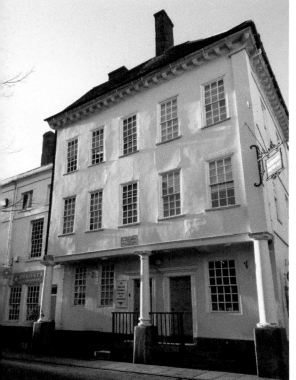

Above: Dictionary of the English Language.
(Photo: Samuel Johnson Birthplace Museum)

Left: The Samuel Johnson Birthplace Museum.

to London with his friend David Garrick in 1737 but again struggled to establish himself as a writer in the capital. It was only when he was approached by a number of publishers in 1746 to produce a comprehensive and detailed dictionary that he eventually became well known across the country.

It took Johnson and his team of six assistants eight years to complete and the dictionary was eventually published in 1755, becoming the most noted and respected dictionary of its age. It also made Johnson one of the most celebrated men in the whole of London. His friends were the elite of London's society, including Joshua Reynolds, Edmund Burke, Oliver Goldsmith and Adam Smith – all members of 'The Club', a private members group by invitation only, who met at the Turk's Head pub in Soho, London. Despite his fame, Johnson was never a wealthy man and it was only when awarded a pension by King George III that he was able to live a relatively comfortable life.

Johnson always retained his love of Lichfield and would return to his home city on a regular basis to see his friends and relatives. One particular friend was Miss Molly Aston of Stowe House, whom he visited regularly to enjoy her vivacious attitude and witty remarks.

Below left: Statue of Samuel Johnson, Market Square.

Below right: Statue of Samuel Johnson, Lichfield Cathedral.

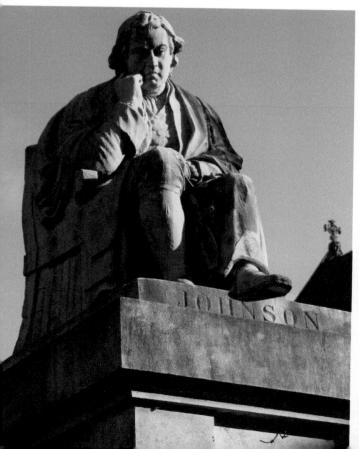
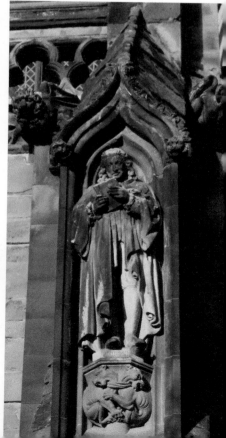

Johnson died on 13 December 1784 and was buried at Westminster Abbey, alongside his friend David Garrick.

There are many Johnsonian connections and references in Lichfield. As well as the Birthplace Museum, his imposing statue on Market Square and another statue on the south side of Lichfield Cathedral, a local hospital and a pub at Netherstowe are also named after him. It is true that Samuel Johnson is the foremost figure from Lichfield's history and whenever you visit Lichfield you are always aware of his presence and of his achievements.

J. W. Jackson

One of the many people who have written about Samuel Johnson over the past 300 years was Mr J. W. Jackson, a former Lichfield city librarian. Throughout the 1930s and 1940s, Jackson wrote a column in the *Lichfield Mercury* covering all aspects of Lichfield's history under the heading 'Historical Gleanings'.

His column always listed him simply as J. W. Jackson but his full name was John William Jackson. He was born in 1864, in Brereton, Staffordshire, but moved to Lichfield with his family at the age of two. He attended the National School on Frog Lane and then Thomas Minor's School on Bore Street, where his teacher was the wonderfully named Sylvanus Biggs.

He studied music at Trinity College and taught the music class at the Municipal School of Art in Lichfield for ten years. He was a proficient organist and played at Christ Church, Leomansley, for many years. He lived at No. 16 Beacon Street and for nearly ten years he was the librarian at the Free Library Museum on Bird Street, close to his home. It was there that he accessed many historical books and journals and created a huge archive of historical information about Lichfield. He published a book called *Lichfield Historical Incidents, Trusts and Charities*, and books on the siege of Lichfield at the time of the English Civil War and the mansion halls of Lichfield. During his time as a features writer for the *Lichfield Mercury* he wrote many articles on the history of Lichfield, many from the historical records and books of the day but also, having lived in Lichfield since 1866, from his own personal recollections. He often focused on themes, so typical features would be about old trades and tradesmen, the old soldiers, the old athletes and the old streets of Lichfield. He also wrote about the traditions and customs of Lichfield, such as the Court of Arraye, St George's Court and the Bower.

In 1940 J. W. semi-retired to Shropshire after seventy years in Lichfield. He continued to write columns for the *Lichfield Mercury* throughout the 1940s however, and passed away in November 1950, aged eighty-eight.

K

The King's Head

The King's Head public house is reputed to be the oldest in Lichfield. Dating back to the early fifteenth century, it was at one time called the Antelope and the Bush but has been called the King's Head since the mid-seventeenth century.

The pub was the location where the Staffordshire Regiment was raised for the first time when, in 1705, Colonel Luke Lillingston raised a regiment of foot. By 1751 it had become the 38th Foot Regiment and in 1783 was the 1st Staffordshire Regiment. The regiment is now part of the Mercian regiment.

During the Georgian period, the King's Head was one of the principal coaching inns of the city. Located on Bird Street, it was on the direct route for coaches travelling to and from London and the south, via St John Street, and those serving the northern towns of Chester and Liverpool via the Stafford Road. Along with the George Hotel and the Swan Hotel on the same street, it competed for the wealthy trade that the coaches brought into the city. The competition sometimes got out of hand as the stable boys of each of the pubs would sometimes settle their differences with a bout of fisticuffs, often claiming that one pub had stolen another's customers!

The pub is one of several in Lichfield that is claimed to be haunted. A mortally wounded Royalist soldier from the English Civil War is seen to stagger out of the King's Head and onto the street, and the ghost of a maid who was killed in a fire is seen at an upper window holding a flickering candle.

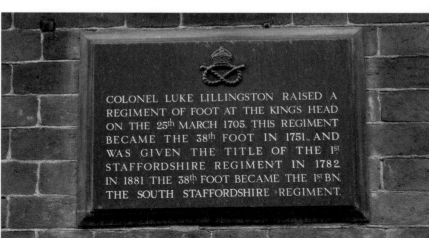

Colonel Luke Lillingston plaque, the King's Head.

COLONEL LUKE LILLINGSTON RAISED A REGIMENT OF FOOT AT THE KING'S HEAD ON THE 25th MARCH 1705. THIS REGIMENT BECAME THE 38th FOOT IN 1751, AND WAS GIVEN THE TITLE OF THE 1st STAFFORDSHIRE REGIMENT IN 1782. IN 1881 THE 38th FOOT BECAME THE 1st BN. THE SOUTH STAFFORDSHIRE REGIMENT.

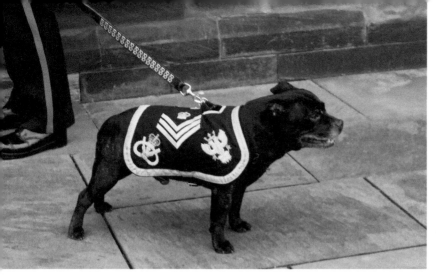

Watchman, mascot of the Staffordshire Regiment.

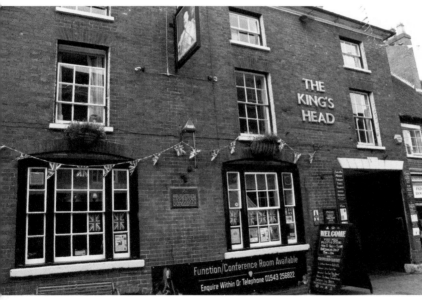

The King's Head public house on Bird Street.

The pub's current landlords are former veterans of the Staffordshire Regiment who put together a consortium to buy the pub and now actively promote the past traditions and history of the regiment.

Colonel Kilian

One of the most infamous men in Lichfield's history was the American Colonel James Kilian, once considered to be a well-liked and popular hero by the people of Lichfield, but his reputation was tarnished by a shocking revelation. During the Second World War, Kilian had been the commander in charge of the 10th American Replacement Depot at the Whittington Barracks, a short distance outside Lichfield. The Replacement Depot

was a holding point for reserve US troops who were ready to replace front-line troops as and when required. The depot had been operating since mid-1942 as the American forces started to pour into the European battlefields. Colonel Kilian and the American troops had, initially, been very popular in Lichfield. He would arrange for local people from all walks of life to be transported to the barracks, where they would be given a Sunday dinner with all the trimmings – something that the people of Lichfield were not used to in the days of shortages and food rationing. At Christmas he would lay on a party for the children of the city, with presents, sweets, candy and entertainment.

In 1944 the 10th Replacement Division was awarded the Freedom of the City. This was a great honour for the regiment, and for Kilian, as that privilege had been awarded to only six people previously, the first being Lieutenant-Colonel John Gilbert in September 1900. On 22 December 1944 nearly 1,000 US troops paraded through the city streets with drums playing and the Stars and Stripes flying on every street corner. After the procession there was a presentation ceremony at the Guildhall on Bore Street. The Mayor of Lichfield, Councillor Thomas Moseley, presented Kilian with an ornamental scroll held within an oak casket made by Robert Bridgeman and Sons, the Lichfield woodcarvers. Both the mayor and the colonel praised the mutual respect and admiration that they held for each other. Kilian said that, despite the horrors of the war, both he and his troops had been made to feel very welcome in Lichfield, forging a permanent and long-lasting friendship between them. The ceremony was broadcast live on BBC radio and was also transmitted across to the BBC service in the United States.

American troops were not always universally welcomed in Britain but it seemed that in Lichfield at least they had found a home from home. However, when the war ended in

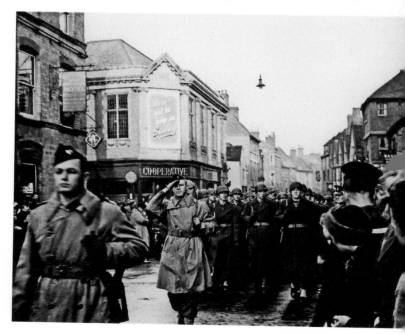

American troops march through Lichfield, December 1944. (Photo: Lichfield City Council)

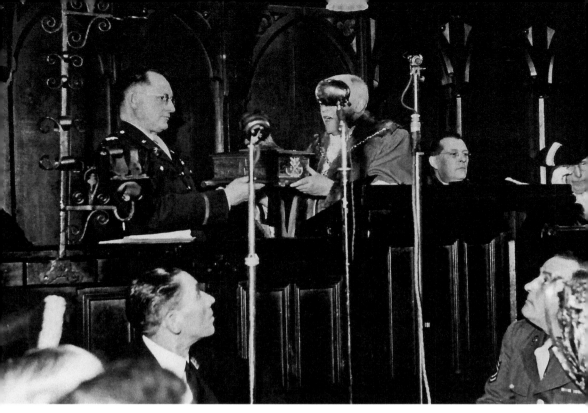

Colonel Kilian accepts casket from the Mayor of Lichfield, December 1944. (Photo: Lichfield City Council)

1945, stories started to emanate from America about the treatment of the US personnel while under the command of Colonel Kilian at the Whittington Barracks. Allegations of brutality were made by soldiers who had been held as prisoners in the guardhouse of the depot, claiming they had been beaten with clubs and tortured by NCOs at the camp. There were claims that soldiers were made to stand with their faces directly against the walls of the guardhouse for hours with no respite and that they were routinely beaten for minor misdemeanours. It was also said that many NCOs were reduced in rank, from sergeant to private, without any justification. In light of these very serious allegations a war crime trial was held in September 1946 at Bad Nauheim, Germany. Colonel Kilian was brought to trial, along with nine enlisted guards and three of his junior officers, and charged with the cruel punishment of the soldiers under their care. On the charge of aiding, authorising and abetting the cruelties Colonel Kilian was acquitted, but he was found guilty of permitting the cruelty to be carried out at the camp. He was fined £125 and given a reprimand, though he was allowed to retain his rank and pension. After the trial he was recommended for promotion, although this was subsequently overturned by the American president, Harry S. Truman. Of the co-accused guards and NCOs, most received minor fines or reprimands and only one was dismissed from the army.

Although it is not known exactly how much, if anything, Colonel Kilian knew about the cruelty that took place within the camp he did, as the camp commandant, have the ultimate responsibility for the actions of all the staff under his control.

Gregory King

Gregory King was a seventeenth-century genealogist, statistician and engraver. Born in the parish of St Chad's at Lichfield in December 1648, he was educated at Lichfield Grammar School, now home to the offices of Lichfield District Council, where he learned Latin and Greek. On the recommendation of the headmaster, the Revd John Hunter, he was appointed clerk to the antiquary Sir William Dugdale at the age of fourteen. Later, King worked as a secretary to Lady Gerard, widow of the 4th Baron Charles Gerard, at Sandon Hall in Staffordshire. He moved to London in 1672 to work with the printer John Ogilby as an engraver. King also had a career in public service as a commissioner, working on projects involving a new tax calculation, births and burials and a study on the population of England. In 1695 he produced a statistical document on the city of Lichfield, detailing the population and listing names of all of the inhabitants. In total there were 655 houses and 3,038 inhabitants, giving an average of 4.64 persons per household. The population of Lichfield at the 2011 census was approximately 32,000.

King was married twice, first to Anne Powel and then to Frances Grattan with whom he had three children who all died in infancy. He died on 29 August 1712.

The former Lichfield Grammar School.

Revd Chancellor James Thomas Law

The Revd James Thomas Law was one of Lichfield's greatest benefactors, although he is someone that many local Lichfeldians are unaware of. He gifted the statue of Samuel Johnson that stands on Market Square to the people of Lichfield, he assisted with the building that became only the second free library in the country, he provided the fountain that stands in the Museum Gardens and even when he died he continued to help the people of Lichfield with a gas-lit illuminated clock on his mausoleum. He was born in December 1790 and was the son of the bishop of Bath and Wells. He took holy orders in 1814 and moved to Lichfield in 1821 where he became Chancellor of the Diocese of Lichfield at the age of just thirty-one. The Diocese of Lichfield was, and still is, one of the largest in the country, with an area of responsibility stretching out to the Welsh borders, up to Cheshire and across the West Midlands and the Black Country. Today it is responsible for the administration of over 800 churches and chapels. This was therefore a very responsible position for someone of his tender years.

Law became one of Lichfield's most generous benefactors and in 1838 he provided the money for the statue of Samuel Johnson on Market Square. The statue, created by Richard Cockle Lucas, cost approximately £1,000, which was then a very substantial amount of money. When the statue was officially unveiled a large crowd gathered on Market Square, and the ceremony was followed by a dinner with music and dancing at Lichfield Guildhall for the invited guests.

Law was a man of the people and was very concerned about the poverty of some of the working-class inhabitants of Lichfield who did not have enough money to provide food for their families. He wrote a paper on the benefits of cultivating allotments so that poorer families could grow their own fruit and vegetables and, as a significant landowner in and around the city, he let out strips of land for use as allotments at half the rate that other landowners were charging at that time.

Law was a driving force of the construction of the Free Library and Museum on Beacon Street, serving on the management committee that oversaw the building of the library. In 1871 he provided the fountain that stands in the grounds of the Museum Gardens in Beacon Park and, at the opening ceremony, led a parade round and round the newly installed fountain singing hymns! Today it is still known as Law's Fountain and the base of the fountain bears an inscription to him.

Law resigned his position of Chancellor of Lichfield Diocese in 1873 at the grand old age of eighty-three, a post he had held for an impressive fifty-two years. When his wife Catherine died in 1866 he had built a mausoleum for both himself and his wife in the graveyard at St Michael's Church at Greenhill. The position that he chose for the mausoleum was, surprisingly, at the furthest point away from the church itself, in a quiet corner of the graveyard. Law had chosen this location specifically, though, as it was very close to the junction of Church Street and the Burton Road. Workers in the farms and shops of Lichfield would walk past early in the morning and late in the afternoon on their way between the city and the Trent Valley railway station, half a mile from the city centre. On the top of the mausoleum, facing out towards the roads below, Law had arranged to fix two oil-filled clocks. These were to be lit at night so that passers-by on their way in and out of town would be able to see the time. This was especially important as many people in those days would not be able to afford or have access to a pocket watch.

In 1876 Chancellor James Thomas Law passed away, aged eighty-six, but his legacy remains in Lichfield. The statue of Lichfield's most famous son, the Free Library and Museum building, the Law fountain in Beacon Park and the Law family mausoleum are all still in place and provide a series of iconic buildings and sculptures that form a major part of the essence of Lichfield's history.

Below left: James Thomas Law fountain, Beacon Park.

Below right: James Thomas Law mausoleum, St Michael's Church.

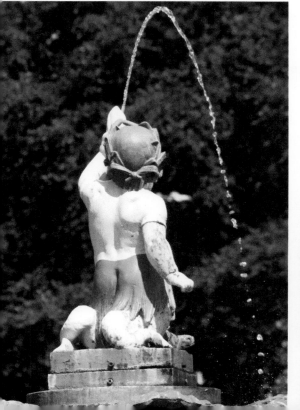
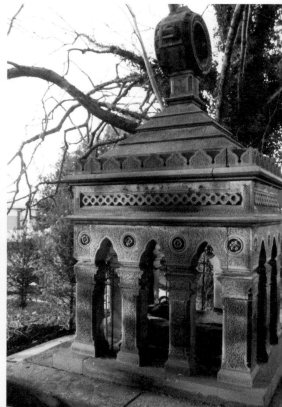

Sophia Lonsdale

Sophia Lonsdale was an influential speaker on the rights of workers and on poor law reform; she was also strongly against the female suffrage movement. Born in 1854, she was the daughter of John Gylby Lonsdale, a canon of Lichfield Cathedral for over fifty years and the vicar of St Mary's Church for twenty years. Her grandfather was John Lonsdale, a former bishop of Lichfield.

She was one of the founders and supporters of the Girls' High School, which opened in 1892 on Market Street, and a leading campaigner for reform of the Poor Law. In 1895 she published a pamphlet, *The English Poor Laws: Their History, Principles and Administration*, outlining her ideals. She was a staunch opponent of the female suffrage movement and wrote to the press, including *The Times* newspaper, in 1907 to start a petition and asking for women to add their signatures to it. Her letter stated that while she recognised the importance and value of women's work in national life she strongly objected to women's suffrage. She argued that giving women the right to vote would 'destroy, rather than add to, their real influence in their own sphere of work in the world'. Her petition gained many thousands of signatures and she claimed that all the learned women of her home city of Lichfield that she knew personally were against the suffrage movement.

In 1907 her father died and she left Lichfield to move to London. She worked for the National Charity Organisation while continuing to provide talks and lectures on the Poor Law Reforms. She died in Weybridge, Surrey, in 1936 at the age of eighty-two and her cremated remains were interred at a ceremony in Lichfield Cathedral.

Lichfield Libraries

One of the earliest free libraries in the country was opened in Lichfield in 1858. Before the introduction of the free libraries scheme, public libraries in England were fee paying. Circulating or Permanent Libraries provided access to books and journals but they charged a monthly or yearly fee to subscribers, which meant that only the wealthy could afford to join. In Lichfield, circulating libraries were operated by Henrietta Shaw on St John Street and Sarah Goodwin on Bird Street. The Revd James Thomas Law, Chancellor of the Diocese of Lichfield, had a permanent library at his home on Market Street.

In 1850 the Public Libraries Act was passed in Parliament, strongly advocated by Scottish MP William Ewart. It granted corporations and local councils the opportunity to open free libraries for the first time. Lichfield was one of the first places to react to the new Act and a committee was put in place to look at the various options. The committee considered using existing buildings as a site for their new library but Chancellor James Thomas Law agreed to transfer to the Corporation, for a nominal fee, an area of land he owned on Bird Street, close to Beacon Park, so that a new, purpose-built, library could be erected.

In 1857 work started on the new library building and it was also agreed that the building would contain the city's museum collection. With the land in place, the monies for the building came from public subscriptions and donations. The architects appointed were Bidlake and Lovatt of Wolverhampton, who had been responsible for the design of many buildings in the Midlands area. The building was constructed to an Italianate design, a style more frequently seen on the south coast but rarely in the Midlands or the North, and was officially opened in April 1859 in front of large crowd. The library was on the ground floor and the museum on the upper floor. It was only the second free library to open in the country, the first being in Salford, Manchester. After it opened another fund was started to provide books and facilities for the library and many old Lichfeldians left donations of books to the library as provisions in their wills. The new library was not universally welcomed because of the cost of its upkeep. One of the provisions of the new Act enabled local corporations to increase taxes in their district to pay for the increased expenditure. Taxes were increased by half a penny and then a penny to fund the new buildings. Although a very small sum today, to a poor family in 1859 a penny increase was significant when the average wage in the country was less than £50 a year. Many working-class people had no interest in reading and there were still numbers of people who could neither read nor write. Many people objected to the increase in tax being forced upon them for a service that they had no intention of using.

The Free Library and Museum continued to house the library until 1989 when it relocated to the Friary building recently vacated by the Friary School when it moved to new premises on Eastern Avenue.

In 2018 the library moved to its current location at St Mary's Church on Market Square and in 2019 Lichfield will celebrate the fact that there will have been a free library in the city for 160 years.

Free
Library and
Museum,
Beacon Park.

Market Street

Lichfield's Market Street is filled with a variety of independent shops, pubs and retailers and is one of the most vibrant shopping streets in the centre. It links Bird Street with Market Square and, during the eighteenth century, was called Saddler Street because there were a number of leather shops and workshops on the street at that time. It had also been called Robe Street for a short period. The layout of Lichfield streets had been formed in the twelfth century under the stewardship of Roger de Clinton, bishop of Lichfield. The layout is essentially a ladder shape, with the staves being Bird Street and Conduit Street/Dam Street and the rungs being Market Street, Bore Street, Wade Street and Frog Lane.

Market Street.

One of the longest-serving shops on Market Street was Mounsdon and Sons wine shop. In 1882 Henry Mounsdon opened premises as a wine and spirit merchant at No. 33 Tamworth Street. In 1906 you could purchase brown or pale sherry, special luncheon clarets, hocks and Moselles as well as old Scotch and Irish whiskies at 36 shillings for a dozen bottles – around 15p per bottle today! Mounsdon's later moved to No. 9 Market Street, which subsequently became a Victoria Wine shop and is now an optician. Mounsdon's son, Ernest, continued the family business with a shop on Lichfield Street in nearby Tamworth.

Thomas Minor

Thomas Minor's School was a seventeenth-century schoolhouse founded by Thomas Minor, a merchant and politician. Thomas was born in 1606 to a family of landed gentry whose fortunes and wealth had started to decline. He lived on Saddler Street, which is now Market Street, and worked as a draper. He was appointed Sheriff of Lichfield in 1642 and in 1654 he was elected Member of Parliament for Lichfield at the first Protectorate Parliament after the English Civil War. He lost his seat in 1660 to Daniel Watson but he regained it following a petition. In 1657 he became a Justice of the Peace for Staffordshire and served on a number of commissions. He was ordained as a Presbyterian minister and, in 1669, appeared before the Privy Council accused of keeping unlawful meetings at his house. Thomas was married twice, firstly to Sarah Burnes and then to Dorothy Jesson, both of Lichfield. In 1670 Minor established a schoolhouse at the junction of Bore Street and St John Street to be used to educate thirty poor boys of Lichfield so that they were able to read the Bible. The school was closed in 1876 and was demolished at the start of the twentieth century; an estate agents now stands on the site of the original building. Thomas died on 30 September 1677 and was buried at St Mary's Church.

Site of the former Minor's School.

St Mary's Church

St Mary's Church is a Gothic Revival building on Market Square. There has been a church on that site since medieval times and it is possible that a church was already in place there in 1150 when Bishop de Clinton laid out his plan for the city's streets. A fire that swept through the city in 1291 burnt down all its churches however, and St Mary's was rebuilt in 1536. At this time the Guilds of St Mary's and St John the Baptist ran the affairs of the city. The two guilds, associations of merchants and tradesmen, merged and oversaw the local administration of the city until the sixteenth century. The church regularly suffered damage, and the spire fell down in 1594 and again in 1626. In 1716 a further spire fall led to the decision to demolish the church in its entirety. A new church was designed by the architect Francis Smith of Warwick; construction started in 1717 and was completed in 1721. Repairs were made to the church in 1806 and 1820 by Joseph Potter Senior, a Lichfield architect. In the late nineteenth century the church was rebuilt after the death of the vicar, the Revd Henry Lonsdale in 1851. Initial designs were produced by the architect George Edmund Street and work started on the new church in 1853. Initially the tower was rebuilt, in a Victorian Gothic style, and a steeple or spire was installed. However, funds for the work on the main body of the church then dried up and no further work took place until 1868. The architect of the next stage of the work was James Fowler of Louth in Lincolnshire. Although he ran his business from Lincolnshire, Fowler had been born in Lichfield in December 1828. Most of the cost of the work was met by the Lonsdale family. The Revd Henry Lonsdale was the brother of Bishop John Lonsdale and when he died in 1867 he left a large estate. His son, Canon John Gylby Lonsdale, dedicated funds to the building of St Mary's Church as his father had always been a strong supporter of the church. In 1868 the old church had been demolished and a stone-laying ceremony for the new building took place in July. The church was reopened on 21 April 1870 in the presence of the bishop of Lichfield, George Augustus Selwyn.

St Mary's
Church on the
Market Square.

By the 1930s the number of people living in the city centre had declined as shops and businesses replaced residential homes. The congregation of St Mary's gradually reduced as people used the parish churches outside the city centre. In the 1970s the church numbers had fallen so low that it was hardly being used and a committee worked on plans to change the use of the church from a place of worship to a multi-purpose community facility to avoid the building closing down completely. Work started in 1978 to convert the building to accommodate a social centre for senior citizens, a café, a shop and, in the upper floor, a museum. The building was opened as the St Mary's Heritage Centre in 1980 and the Dyott Chapel at the north side of the building was retained as a place of worship, with occasional services held during the year.

In recent years, changes in the retail industry and an increase in the number of cafés in the city centre meant that the retail element of St Mary's struggled, but in 2017 its fortunes were revived with the announcement that Lichfield Library would be moved from its location on The Friary into the ground floor of St Mary's. At the same time the upper floor would be transformed into a performance and arts space with an area for displaying art and media. After an extensive refurbishment, which included removing many of the partitioned areas that disguised the original elements of the church, the new facility was opened in December 2018.

Jonathan Mallet

Jonathan Mallet was an army surgeon from a well-known Lichfield family who served in the American War of Independence and once lived in the same property as the renegade American general Benedict Arnold. Mallet was born in Lichfield in 1729 and was baptized in St Mary's Church on Market Square. His father and grandfather had both been Sheriff and Mayor of Lichfield, and all three generations shared the name Jonathan. His grandfather had married Anne Deakin, one of the servants of Michael Johnson, Samuel Johnson's father. It is not known where Jonathan studied medicine but by 1757 he was serving as Surgeon to the 46th Regiment of Foot in America. He married Catherine Kennedy, the daughter of a wealthy customs collector, in New York in 1765 and they lived for a time at No. 3 on the Broadway. When Benedict Arnold defected to the British side he also lived at No. 3. Although it is not known whether they lived there at the same time, Jonathan Mallet looked after the medical affairs of Arnold's widow, Peggy Shippen Arnold. Mallet provided medical support at the bloody siege of Bunker Hill near Boston in 1775 and was later appointed Chief Surgeon to the Hospital in Boston, effectively becoming the chief medical officer of the army in the town. In 1783 the American War of Independence ended and Mallet returned to England, arriving back in London in 1784. After a period of semi-retirement he was appointed as Quarter-Master of the Volunteer Infantry at Lichfield in 1803 at the age of seventy-two. His last years were spent in London and he died at his home in Brynaston Street on 21 November 1806.

Newton's College

Newton's College lies within the Cathedral Close, and was formerly an almshouse. Andrew Newton, the brother of Thomas Newton, Bishop of Bristol, was an ale and wine merchant in Lichfield. In 1800 he provided £20,000 to build an almshouse providing accommodation for the widows and daughters of the clergy of the cathedral and the

Below left: Birthplace of Bishop Newton, brother of Andrew Newton, Bird Street.

Below right: Memorial to Andrew Newton, Lichfield Cathedral.

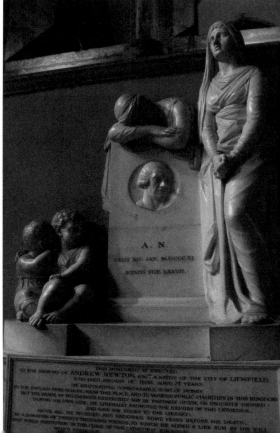

Newton's College, Cathedral Close.

churches of St John's and St Mary's. The building, comprising twenty individual dwellings, was designed by the noted Lichfield architect Joseph Potter Senior, who had worked with the architect James Wyatt and had been responsible for several other buildings in Lichfield including St Mary's Church. Prospective residents were required to be at least fifty years of age, of good character, members of the Church of England and to have no income of their own exceeding £30 per annum. In addition to the building itself, Newton left a provision of £50 per annum endowment to each of the residents. Today the property is administered by the Office of the Dean and Chapter of Lichfield Cathedral and occupied by both men and women without the qualification restrictions of the 1800s. A memorial to Andrew Newton in the south transept of Lichfield Cathedral was sculpted by Richard Westmacott.

King Offa

King Offa was a Mercian king who reigned between 757 and 796. In 787 Pope Adrian I elevated the diocese of Lichfield to an archdiocese at the request of King Offa, thereby replacing the authority of Canterbury with that of Mercia. However, when Offa died in 796 Lichfield lost that status, reverting to a diocese. A statue of Offa appears on the west front of Lichfield Cathedral, close to the statue of St Chad.

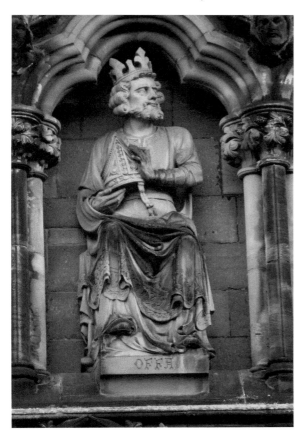

King Offa statue on Lichfield Cathedral.

Old Father Time

One of the largest and most impressive statues ever to appear in Lichfield was known locally as 'Old Father Time'. The statue was created by the Italian sculptor Donato Barcaglia, and is officially named *Donna che trattiene il tempo*, or *The Beauty Who Holds Back Time*; however, most Lichfield people called it Old Father Time! It depicts a beautiful young girl desperately trying to hold back Father Time as he moves powerfully forwards, in a vain attempt to stop the passage of time and retain her youthful good looks. Standing 8 feet tall and made of white marble, it is a striking and powerful piece of art.

It was bought by Colonel Michael Swinfen-Broun of Swinfen Hall, who was a collector of artefacts, paintings and sculptures. The statue remained in the family home until the 1940s when he bequeathed it and other collectables to the city of Lichfield before he died. It formed part of a museum collection firstly of Lichfield City Council and then Lichfield District Council. It was housed initially at the Free Library and Museum on Bird Street and later for a time at the National Memorial Arboretum at Alrewas. When a new home could not be found for the statue, due to its size, it was held in storage for a number of years before being sold at Sotheby's in London in 2008. Although it is no longer in Lichfield it is still fondly remembered by many Lichfeldians and is sadly missed.

The Old Crown Hotel

The Old Crown Hotel was one of Lichfield's many public houses. Formerly known as the Old Crown Commercial Hotel, it was put up for auction in 1862 when the proprietor of many years had left, and was listed as an old established hotel, close to the South Staffordshire and London and North-Western Railway, and the centre of the corn market. The Corn Exchange building on Conduit Street was only 200 yards away, and the Old Crown was frequented by the principal agriculturists and traders of the day. In the 1980s the pub rather mysteriously collapsed overnight, just as it was about to be renovated. The structure was rebuilt and now houses an opticians' practice.

Dame Oliver's

When Samuel Johnson was a small boy he walked the short distance from his home on Breadmarket Street, across Market Square and along Dam Street to attend a school run by Dame Oliver. Ann Oliver, the widow of a shoemaker, ran the school for young children in a small cottage at No. 10 Dam Street. Johnson had been a sickly young child with a number of illnesses and his school chums sometimes lifted him onto their backs to carry him from his home to the school and back. When he did walk he was sometimes followed by the family's maid, worried that he may not be able to get to the school safely. This infuriated the young Johnson and he would order her not to

Above left: Dame Oliver's School on Dam Street.

Above right: Friends carrying Samuel Johnson to school. (Photo: Samuel Johnson Birthplace Museum)

follow him. Even after she was banned from doing so she would sometimes track him at a safe distance, hiding behind trees and buildings so that he would not spot her!

After he left the infant school Samuel furthered his education at the Lichfield Grammar School on St John Street. Johnson later told his friend James Boswell that Dame Oliver came to see him before he left Lichfield for London and that she gave him a present of some gingerbread, telling him that he had been the best pupil she had ever taught!

Today the old cottage in Dam Street houses a sweet shop, and a stone plaque set in the wall indicates its former use. There is now a ladies' dress shop further along Dam Street called Dame Oliver's.

P

Sir William Parker

On 13 November 1866, Sir William Parker passed away at the age of eighty-five, becoming the last of the naval captains who had served under Lord Horatio Nelson to die. Parker had been born on 1 December 1781 and started his naval career as a captain's servant at the time of the French Revolution. During the Napoleonic Wars he was the captain of his own ship, HMS *Amazon*. In 1805, just before the Battle of Trafalgar, the *Amazon* was sent on other duties and so missed taking part in one of the most famous battles in naval history. However, Parker captured two French ships, *Marengo* and *Belle Poule*, in 1806. In 1812 he was put on half-pay and eventually left the navy, buying Shenstone Lodge as his family home. Parker's parents had lived in the Cathedral Close at Lichfield and he settled down to life as a country gentleman in the village of Shenstone, a few miles outside the city.

In 1827 he was tempted out of retirement to return to the sea as captain of HMS *Warspite*. He served briefly as Second Sea Lord in 1834 and 1835, before becoming Vice Admiral of the Navy in 1841 during the First Opium War with China. Due to his successful campaign against the Chinese, he was awarded a baronetcy in December 1842 and appointed Knight Grand Cross of the Order of the Bath. In April 1863 he was made Admiral of the Fleet, a very high honour. He was buried in the graveyard of St John the Baptist Church in Shenstone and there is a large marble monument to him in Lichfield Cathedral. Today the site of Parker's former home at Shenstone Lodge is a school.

Pools of Lichfield

Minster Pool and Stowe Pool are man-made pools that traditionally provided the water supply to the people of Lichfield.

Stowe Pool, sometimes called Stow Pool, was formed in the eleventh century when a dam and a mill were constructed. During the thirteenth century the pool became a fishery, first under the control of the bishop of Lichfield and passing to the control of the city in the sixteenth century. The pool continued as a fishery until 1856 when

Stowe and Minster Pools plaque, Reeve Lane.

the recently formed South Staffordshire Water Company took control so that it could be used to supply water to the Black Country area of the West Midlands. The water was routed to a pumping station at Sandfields, just outside the city centre, where it was then directed to Walsall. This continued until 1968 when there was no longer a need for the supply to the Black Country and control of the pool was returned to the city. Today Stowe Pool is a recreation facility looked after and maintained by Lichfield District Council.

In January 1821, five young boys were taking advantage of the recreational facilities of the time by sliding across the frozen ice of Stowe Pool when the ice gave way and they fell into the freezing water. They were in the water for some time and there were fears for their safety but eventually they were rescued. Two had to be pulled out using ropes but all five survived the ordeal.

In August 1975 the Lichfield Sailing Club held their fifth annual regatta on Stowe Pool with free boat trips, water sports and a sub-aqua display that proved very popular although boats no longer sail on the water.

Samuel Johnson was a regular visitor to Stowe Pool when he lived in Lichfield, and continued to visit on his regular returns after his move to London. Johnson would often sit beneath a large willow tree on the banks of the pool, and was so fond of the tree that it became known as Johnson's Willow. The tree is still there today; not the original tree though, as willow has a relatively short life and has been replanted at least three times. His father Michael, a bookseller, had a parchment factory alongside Stowe Pool. The factory is long gone, but there is a street called The Parchments in the local area.

Minster Pool was also formed in the eleventh century, fed by small brooks from Leomansley and Trunkfield. In the fourteenth century a causeway was built on what is now Bird Street creating two pools: Minster Pool to the east and the Bishop's Pool to the west. Eventually the Bishop's Pool silted up and in the nineteenth century it was drained and the Museum Gardens were created on the edge of Beacon Park.

Right: Johnson's Willow, Stowe Pool. (Photo: Samuel Johnson Birthplace Museum)

Below: Stowe Pool.

Minster Pool.

In 1772 Anna Seward, the Swan of Lichfield, visited the Serpentine in London's Hyde Park and realised the benefit of the serpentine shape, which helped to reduce the accumulation of silt in the pool. She recommended that Minster Pool be reconfigured in the same shape, and promoted the landscaping of New Walk along the border of the pool, which later became Minster Pool Walk.

In 1896 the pool was being cleared of silt and mud by workmen employed by the South Staffordshire Water Company. The workers often found items stuck in the mud, which they would hand in to the water company. One day a worker found two gold rings and he refused to hand them in, instead taking them to the local police who confirmed that they could not identify the original owners and handed the rings back to him. The water company, believing the rings were their property as they were found within their water, took the worker to the Lichfield Court to force him to hand them over. The judge decided in favour of the workman but the company was insistent and appealed the case to the Staffordshire County court. The judge there ruled that the worker had no more entitlement to the gold rings than the mud on the floor of the pool, all of which belonged to the South Staffordshire Water Company and he overturned the original decision, handing the gold rings to the company – clearly not a case of 'finders keepers'!

Today Lichfield District Council manages Stowe Pool and Lichfield City Council manages Minster Pool.

Stephen Panting

In 1795 Merrial Docksey, the sister of Peter and David Garrick, was involved in a court case with Stephen Panting who had attempted to have the wealth of Peter Garrick's estate redirected into his own pockets. When David Garrick had travelled down to London with his friend Samuel Johnson in 1737 it had been with the intention of Garrick setting up a wine business in London to complement his brother Peter's business in Lichfield. David had much more interest in acting than the wine trade and the London operation of the business soon disappeared, but Peter continued to trade, very successfully, as a wine merchant in Lichfield.

David Garrick had died in 1779 at the age of sixty-one but his brother Peter outlived him significantly. In 1791 Peter had made a codicil to his will leaving sums of money to his sister, but as he grew older his health deteriorated and he started to take advice from a Lichfield apothecary, Stephen Panting. In 1895, shortly before Peter Garrick died, another codicil was made to his will, this time benefitting Stephen Panting and not Merrial. When Peter passed away and the will was read, Merrial Docksey disputed the codicil in favour of Panting and the case went to court. Panting and his counsel claimed that Peter Garrick was of sound mind and judgement when he signed the codicil but Merrial's counsel, Mr Erskine, produced a number of witnesses who said that in the latter years of his life he had become very confused and forgetful. From the evidence produced it seems that Peter was suffering from some form of mental health illness. With an overwhelming body of evidence to suggest that Garrick had not been of sound mind when he signed the final codicil, Panting's counsel decided to withdraw the claim. The case was dismissed and Merrial Docksey was awarded her rightful inheritance.

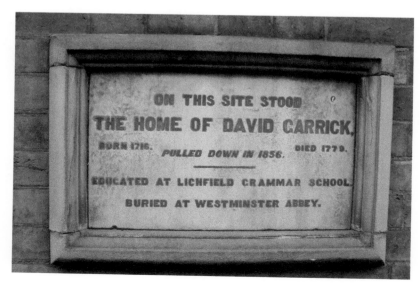

Former home of the Garrick family, Beacon Street.

Quonians Lane

One of Lichfield's quaintest and oldest streets is Quonians Lane, off Dam Street close to Minster Pool and the cathedral. With black and white timbered buildings it is historic and quaint, and is quintessentially English. Robert Bridgeman and Sons, stonemasons and woodcarvers, had premises there, where they produced many statues, woodcarvings and sculptures for Lichfield and throughout the whole country.

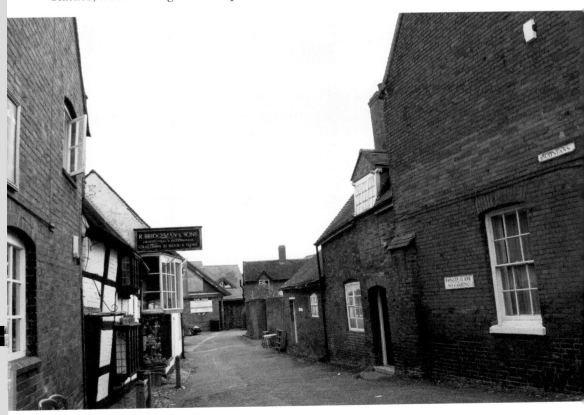

Quonians Lane, off Dam Street.

Quantrill's Butchers

Quantrill's was another of Lichfield's butchers. Henry Walker Quantrill had previously been a hotel keeper at the Old Crown Hotel on Bore Street but by 1885 he was a pork butcher with a business on Market Street. In the 1880s, there were many butchers in Lichfield including Henry Hall's on Conduit Street, Craddock's on Tamworth Street and Rosbrook's on Bore Street, so competition for customers was quite fierce. In 1879 from Quantrill's shop customers could purchase his celebrated pork pies and sausages made from the best country-fed pork, home-cured bacon, hams and pickled tongue.

In 1886 Henry was charged with trespassing while shooting game on land at Elford, a small village between Lichfield and Tamworth. Quantrill claimed that he had spoken to a farmhand before he started hunting, and had used the land, with the permission of the landowner, several times before. The landowner, Mr Paget, a Justice of the Peace, had not been present, but the farmhand agreed it would probably be alright. Unfortunately for Quantrill the judge did not agree, found him guilty of trespassing on the land and fined him five shillings plus costs.

Quantrill later moved his shop from Market Street to Tamworth Street at its junction with Baker's Lane —now the starting point of the Three Spires Shopping Centre. In 1917 Quantrill's was still advertising its famous pork sausages at one shilling and tuppence per pound, and a pound of best bacon was one shilling and sixpence – around 7p in today's money!

Quantrill's kept pigs in buildings behind the shop on Baker's Lane and passers-by would hear them squealing. One of the peak periods for butchers was at Christmas and Quantrill's would display the best of their pigs in the windows and outside the frontage of their shop to tempt the festive shoppers.

In 1940, despite the rationing imposed during the Second World War, Quantrill's told customers that they had plentiful supplies of pork but that it was 'off the coupon', so would not affect their weekly meat ration allowance. Quantrill's continued to trade until the 1960s, when the shop was demolished to make way for the new shopping precinct.

The Queen's Head Pub

Another of Lichfield's many pubs is the Queen's Head, on Queen Street. The original pub with that name in Lichfield was, however, on Bore Street. In 1826 passengers could board a coach and horses that set off at 6 a.m. from the Queen's Head and then travel via Tamworth, Lutterworth, Hinckley, Rugby, St Albans and Barnet before reaching the Golden Cross in London at 9 p.m. – a 15-hour journey. The coach company prided itself on its punctuality and said that arrival would be at 9 p.m. precisely. Being the first to complete the journey between London and Lichfield in a single day,

the company claimed that 'no exertion shall be wanted to make it respectable and at moderate charges'.

When a new Queen's Head was opened on Queen Street, the Bore Street version was renamed the Turf Tavern and, later, the Prince of Wales.

In 1948 the popular landlords at the pub, Mr and Mrs John Rowley, celebrated their golden wedding anniversary. John had been a shoe and boot repairer with premises on St John Street, but the shop had to be demolished in the 1920s to make way for the new Friary Road that was being built. He moved to premises on Dam Street but in 1928 he and his wife took up the tenancy at the Queen's Head. He had been a member of the Special Police Constabulary for over twenty years, was a supporter of the Lichfield Cricket Club and had served on the committee of the Lichfield and District Football League. His wife was a very keen member of the Lichfield Women's Institute and both of them had lived in Lichfield all their lives.

The new landlords in 1969 were Richard 'Mac' MacCormack and his wife Linda. Mac had no personal experience of the brewing trade, although his mother-in-law, Flo Neale, had been the landlady of the pub for the previous fifteen years. An army man, he had served with the Welsh Fusiliers for over twenty years. He was very interested in sport, especially football, and had refereed international matches in Hong Kong as well as being a referee for the local leagues in Lichfield. They planned to make a number of alterations to the pub but Mac's main priority at the time was to put together an eleven-man pub football team! Linda and Mac were another pair of long-serving landlords, finally retiring in August 1993 after twenty-four years at the pub.

Queen's Head public house.

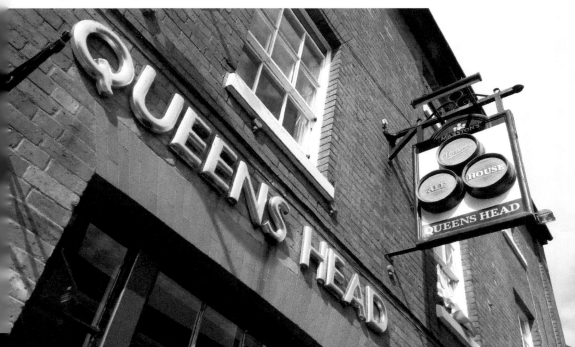

R

Prince Rupert

During the English Civil War, Lichfield Cathedral was subject to a number of attacks from either side, with Royalists and Parliamentarians alternately taking and losing control of the Cathedral Close. In the siege of 1643, when the Parliamentarians were in control, Prince Rupert, nephew of King Charles I, was despatched to regain the close for the Royalist forces. He set up and fired cannon at the defences of Lichfield Cathedral from a mound in what is now the beer garden at the rear of the George and Dragon pub on

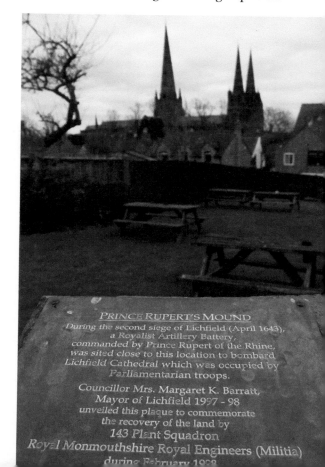

Prince Rupert's Mound.

PRINCE RUPERT'S MOUND
During the second siege of Lichfield (April 1643),
a Royalist Artillery Battery,
commanded by Prince Rupert of the Rhine,
was sited close to this location to bombard
Lichfield Cathedral which was occupied by
Parliamentarian troops.

Councillor Mrs. Margaret K. Barratt,
Mayor of Lichfield 1997 - 98
unveiled this plaque to commemorate
the recovery of the land by
143 Plant Squadron
Royal Monmouthshire Royal Engineers (Militia)
during February 1998

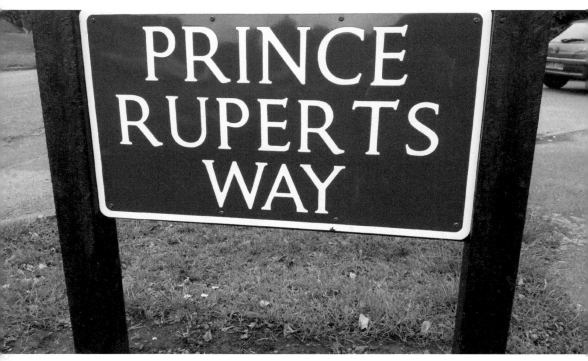

Prince Rupert's Way, off Anson Avenue.

Beacon Street. At a later siege of the cathedral, in 1646, the central spire was brought crashing to the ground. It remained a two-spired cathedral until 1662 when, after the restoration of King Charles II, the third spire was replaced. There is a plaque to Prince Rupert's Mound in the beer garden of the George and Dragon, and there are streets called Prince Rupert Mews and Prince Rupert's Way close to the site of the mound.

Gardens of Remembrance

The Gardens of Remembrance are a lasting legacy to the fallen of Lichfield during the First and Second World Wars. In March 1919 plans were put into place to build a war memorial and garden. The site eventually chosen was in Bird Street, on ground alongside Lichfield's Minster Pool mainly owned by the City Corporation. A sum of £1,200 was raised for the project, mostly from public subscriptions and donations.

The designer of both the garden and the memorial was the architect Charles Bateman. Two ornamental urns and the balustrade around the perimeter of the gardens were provided from Shenstone Court, the family home of Lichfield benefactor Sir Richard Cooper.

The Garden of Remembrance was officially opened on Wednesday 22 October 1920 by the Mayor of Lichfield, Councillor Henry Hall, who formally unveiled the memorial.

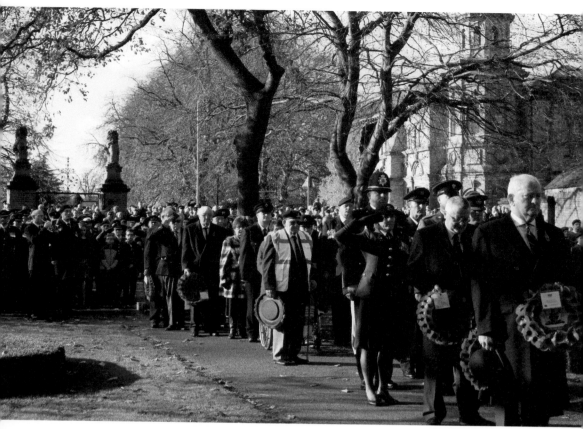

Gardens of Remembrance.

The 219 Lichfield soldiers whose names are listed were either those born within the boundaries of the city or whose house or permanent residence was within the city at the time they joined their regiments.

In November 2018, the 100th anniversary of the ending of the First World War was commemorated at the memorial, when the names of all 219 men and the regiments they served under were read aloud.

Anna Seward

The eighteenth-century writer Anna Seward was known as the 'Swan of Lichfield' and the 'Muse of Britain'. Born in the plague village of Eyam in Derbyshire in 1742, she was the daughter of Thomas Seward who was the rector there. Her father was appointed Canon-Residentiary at Lichfield Cathedral in 1749 and the family moved to Lichfield, living first at No. 15 Market Street before moving into the former bishop's palace in the Cathedral Close.

Anna met Erasmus Darwin, the physician, poet, writer and inventor, who encouraged her to write. It was frowned upon for women to do so at this time, especially for commercial reasons, but by the time she was in her forties Anna had published a number of poems and other written works. She wrote a poem called 'Monody on Major Andre' about her friend, John Andre. Jilted by Honora Sneyd, who

Bishop's Palace, Cathedral Close.

lived with Anna and her family, Andre joined the British Army and became a British spy in the American War of Independence. He became involved in a plot with the renegade American general Benedict Arnold, was captured, and was sentenced to death by the Americans after a trial attended by George Washington. In the poem Anna criticised the Americans for executing Andre and, in particular, criticised Washington for allowing the execution to take place. It was a bestselling work that made her a household name in Britain. Her 'Elegy on Captain Cook' was also very popular and she became one of the best-known writers of the eighteenth century, though today she is relatively unknown, even in Lichfield. Anna also had a long-term friendship with a member of the Cathedral's Vicars Choral, called John Saville. Saville was a married man with children and their friendship created a scandal in the claustrophobic atmosphere of Lichfield. Although Anna's relationship with Saville was never fully defined, they remained close friends until he passed away in 1803. Anna was distraught at the loss of Saville, and there is a memorial to Saville in the south transept of Lichfield Cathedral. Anna lived in her beloved Cathedral Close for over fifty years, rarely leaving its environs and she died there on 25 March 1809.

Below left: Memorial to John Saville, Lichfield Cathedral.

Below right: Anna Seward sculpture, Erasmus Darwin House.

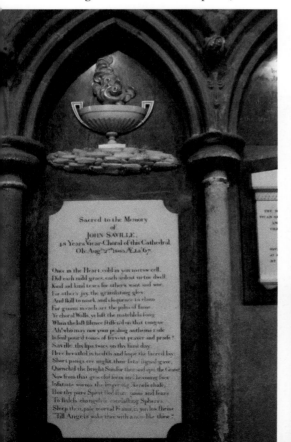

Selwyn 'Spite' House

Selwyn House is at the east side of Lichfield Cathedral Close. It was the family home in later life of a former bishop of Lichfield, George Augustus Selwyn, and and his wife Sarah. When George died his wife Sarah continued to live there and at her death the house became home to students of the Lichfield Theological College. When that closed in 1972 the building became Selwyn Hostel, then Selwyn House, named after the late bishop and his wife. Locals however also know it by another name – Spite House. The story behind this goes back to the eighteenth century when three sisters called Aston, daughters of a wealthy landowner from Cheshire, moved to Lichfield. Two of the Aston sisters bought houses on the far side of Stowe Pool, one named Stowe House and the other Stowe Hill House, where they enjoyed stunning views of the cathedral. The third sister moved in with her sister at Stowe House but they argued constantly. She then moved in with her other sister, a short distance up the hill at Stow Hill House. When she argued with her second sister, she walked back down the hill to move in again with sister one. The arguments and house relocations continued until the third sister, who was independently wealthy, decided to build her own house. She built her new property, a three-storey Georgian building of large proportions, at the east end of the Cathedral Close with the rear

Selwyn 'Spite' House, the Cathedral Close.

of the house looking out over Stowe Pool in the direction of her sisters' houses. When it had been built it blocked the view of the cathedral from her siblings' houses across Stowe Pool. All her sisters could see when they opened their windows was the uninspiring view of the rear of their sister's new house rather than the three spires of Lichfield Cathedral! Locals soon started calling the new house Spite House, thinking it was built out of spite. The story is more legend than fact, and it has been proved that the views of the cathedral from Stowe House and Stowe Hill House are not affected adversely by Selwyn House – but we should not let that get in the way of a good story!

The Sheriff's Ride

The Sheriff's Ride is another of Lichfield's long-standing traditions. Each year, the Sheriff, originally known as the Senior Bailiff in medieval times, rides around the perimeter of the city to 'beat the bounds', making sure that the boundaries are well maintained and not in any danger. In recent years the number of riders accompanying the Sheriff on the ride has increased, and there are sometimes as many as 100 horses present.

Sheriff's Ride outside the Guildhall.

Tudor of Lichfield

The Tudor of Lichfield is one of Lichfield's oldest buildings, built in 1510. Originally known as Lichfield House, in the English Civil War it was used as a prison for both Royalist and Parliamentarian prisoners of war. Some prisoners added seventeenth-century graffiti, cutting their initials into the walls of the cellars where they were kept. It was a private residence for many centuries and in the 1900s was home to Dr James Clark. For twenty-six years Clark had served as the Medical Officer of the Lichfield Rural District Council and was Sheriff of Lichfield in 1888.

The Tudor of Lichfield.

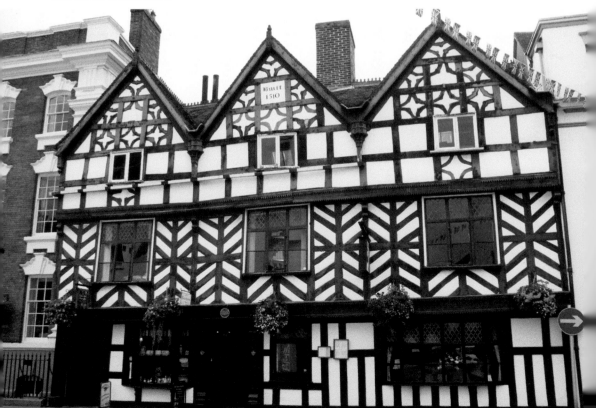

Tudor Row Shops.

It is now the Tudor of Lichfield Tea House and has been owned by the Burns-Mace family since 1936.

An alleyway of shops linking Bore Street to Wade Street opened in 1980, with the entrance at Bore Street by the Tudor of Lichfield. Known as Tudor Row, the alley is filled with lots of local independent shops and during the spring and summer it is festooned with flowers and hanging baskets.

Tanneries

Although Lichfield was never a major centre for industry, there were several tanneries in the city. One was located in Stowe Street, close to Stowe Pool, and water from the pool was used in the tanning process. In January 1839 the Stowe Street tannery was sold by auction at the Old Crown Inn on Bore Street. The auction included the messuage, being a dwelling house with outbuildings and the land assigned for its use, along with eight cottage tenements let at rents producing £49 per year. The tanyard was described as being very complete, with a ring house, currying shop, a bark mill and warehouses. A newspaper listing reported that the tannery was close to water and the canal conveyance, and that the house, cottages and tanyard had a lease of 2,000 years.

The Tanneries,
Cross Keys.

The then owner, Mr Lankester, also offered a dedicated pew at Stowe church (St Chad's) as part of the deal! Today the small alley called The Tanneries that links Cross Keys with Tamworth Street serves as a reminder of the former industry in the area.

RMS *Titanic*

Lichfield has a link to one of the infamous disasters of the twentieth century. In 1914 RMS *Titanic* sank just off the coast of America on its maiden, and as it turned out, final journey. It struck an iceberg and sank to the bottom of the Atlantic with huge loss of life, including that of the captain, Edward John Smith. A statue of Captain Smith stands at the far side of the Museum Gardens in Lichfield's Beacon Park. However Captain Smith had no links to Lichfield, was not born there and, as far as it is known, never even stayed or visited the city. There are two versions as to why his statue stands where it does. The first, and most popular, story is that it was originally intended for Hanley, one of the federation of towns that make up Stoke-on-Trent and the place where Smith was born. However, the people of Hanley were so mortified and embarrassed that Smith was in command of the ill-fated ship when it sank that they started a campaign against the statue being located in or near their town. Lichfield then agreed to have the statue as there was no direct link to Smith that might anger the local people. Although this is quite a dramatic explanation, the truth of the matter is that Lichfield was chosen as the location because the diocese of Lichfield covers a large geographical area and the city is approximately halfway between London, the capital, and the port of Liverpool, which was the home city of the White Star Line, the company that had built the *Titanic*.

The statue was sculpted by Lady Kathleen Scott, widow of Captain Robert Scott, who lost his life on an expedition to the Antarctic, so that the statue is linked by two tragic figures. In 2014 a ceremony was held by the statue to mark the 100th anniversary of the loss of the *Titanic* and was attended by a descendant of Captain Smith.

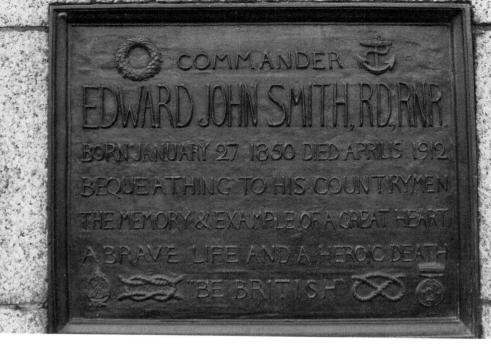

CAPT. OF R.M.S. TITANIC

COMMANDER

EDWARD JOHN SMITH, RD, RNR.

BORN JANUARY 27 1850 DIED APRIL 15 1912

BEQUEATHING TO HIS COUNTRYMEN

THE MEMORY & EXAMPLE OF A GREAT HEART,

A BRAVE LIFE AND A HEROIC DEATH.

"BE BRITISH"

Above: Plaque to Captain Smith.

Right: Captain Smith of the *Titanic* statue, Beacon Park.

U

The Union Workhouse

The Lichfield Union Workhouse stood on the Burton Road close to St Michael's Church, on the site of what is now the Samuel Johnson Community Hospital. Officially opened on 24 May 1840, it was designed by William Moffatt and his partner, the noted Victorian architect Sir George Gilbert Scott, who was responsible

Former Union Workhouse, now Samuel Johnson Community Hospital.

for large numbers of workhouses across Britain and for the redesign of the west front of Lichfield Cathedral. It was one of three workhouses in Lichfield and was designed to house up to 200 paupers. The 1881 census records 145 residents at the workhouse, looked after by a master and a matron. Following the introduction of the National Health Service in 1948 the workhouse became more a hospital than a home for the poor and by 1950 significant changes had been made to the layout and structure of the building. It was known as St Michael's Hospital before becoming the Samuel Johnson Community Hospital in 2005. Although the site has been enlarged over the years it still retains the red-brick structures of the original Victorian building.

The Earl of Uxbridge

Sir Henry Paget, Earl of Uxbridge, served with the Duke of Wellington in 1815 at the Battle of Waterloo. He had been a politician, as Member of Parliament for Carnarvon, and was in military service during the Peninsular War. From 1784 to 1812 he was styled Lord Paget and as the Earl of Uxbridge between 1812 and 1815. One of the most famous exchanges in military history occurred when Paget's lower leg was smashed at Waterloo by a flying French cannonball. It is said that Paget looked down at his shattered limb and exclaimed 'By God Sir, I've lost my leg!' to which Wellington replied 'By God Sir, so you have!'. Following the battle, Paget had several articulated artificial limbs made, including one for riding, a different one for dancing and another for everyday use. Two weeks after the battle, Paget was created Marquess of Anglesey.

The Paget family home was Beaudesert on Cannock Chase, a few miles outside Lichfield and in August 1815, a few months after the Battle of Waterloo, he made a triumphant entrance into Lichfield. Huge crowds, estimated to be nearly 20,000 people, lined the streets on the approach to the city and waited for Paget and his attendants to arrive at St John's Wharf, alongside the Wyrley and Essington canal. The procession was led by a pantaloon caricature of the defeated French Emperor, Napoleon Bonaparte, which had been mounted on a donkey and caused much merriment amongst the crowds. The procession into Lichfield included the Mayor, the Town Clerk, the Recorder and the Mace Bearers. At Bore Street a band played 'See the Conquering Hero Comes' from Handel's oratorio *Judas Maccabeus*, and the official party entered the Guildhall where they enjoyed a fine dinner. After a welcoming speech by the town clerk, the Earl replied indicating that he had been very moved by the warm welcome from the city, and people, of Lichfield.

Henry Paget died in April 1854, aged eighty-six, at his home in London, but he was buried in the family vault at Lichfield Cathedral and there is a memorial to him in the south transept.

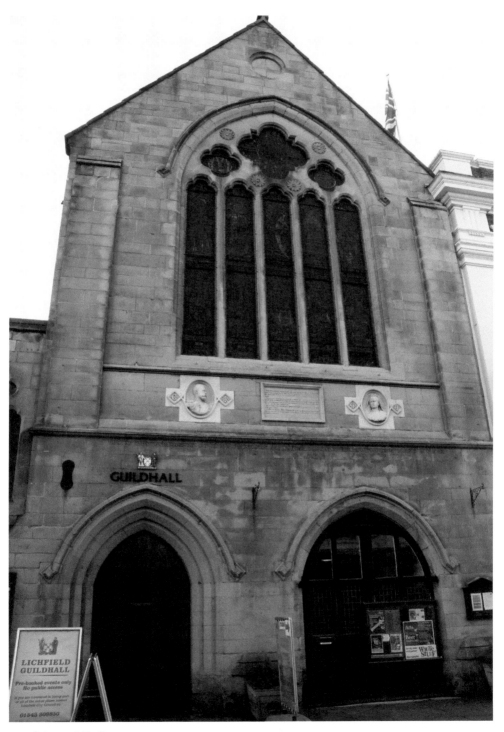

Lichfield Guildhall, Bore Street.

V

Queen Victoria

Victoria visited Lichfield twice, as a princess on 26 October 1832 and later as queen. In 1843 Queen Victoria arrived at Lichfield in the company of Prince Albert, Sir Robert Peel and the Duke of Wellington, hero of Waterloo, following a visit to Tamworth. She was said to have been very disappointed at the condition of the cathedral. Many of the medieval statues on the west front that had become damaged through ageing

Below left: West front of Lichfield Cathedral.

Below right: Queen Victoria statue on Lichfield Cathedral.

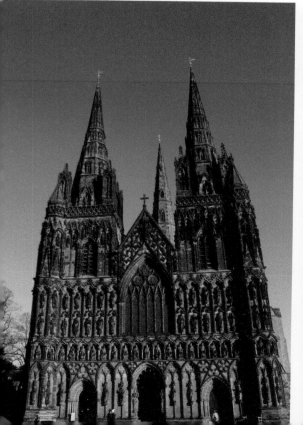

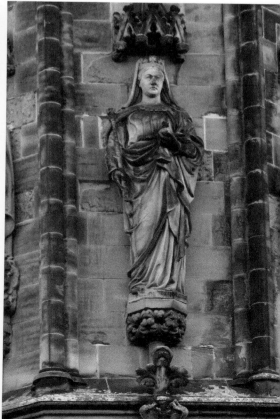

were held in place by the application of very rudimentary cement, and the inside of the cathedral had been whitewashed, giving it a basic and unflattering appearance. Restoration work commenced in 1857 under the supervision of the architect Sir George Gilbert Scott, and was not complete at Scott's death in 1878. The project continued under the supervision of his son, John Oldrid Scott, and included the replacement of most of the statues on the west front, numbering well over 100 in total. The majority of the new statues were produced in the workshops of Robert Bridgeman and Sons on Quonians Lane but one notable exception is the statue of Queen Victoria herself that was sculpted by Princess Louise, one of Victoria's daughters.

The Victoria Hospital

Lichfield has always been considered a loyal royalist city, and several buildings are named after members of the royal family. One of the former hospitals of Lichfield was named to honour Queen Victoria. The original Victoria Nursing Home was established in 1899, in a single house at No. 15 Sandford Street, using funds raised by subscriptions and donations at events organised for the celebration of Queen Victoria's Jubilees in 1887 and 1897. The originator of the home was Canon Melville Scott, who had been vicar of St Mary's Church from 1878 to 1894. One of the main benefactors was Mary Slater, who had left a large inheritance to the nursing association. The nursing home was expanded in 1909 to provide an operating theatre and additional rooms for living accommodation, and renamed the Victoria Nursing Home and Cottage Hospital. In 1933 the hospital moved from Sandford Street to a new location at The Friary and was renamed the Victoria Hospital. The new hospital contained thirty-four beds and had been built at a cost of £25,000. It was opened on 1 July 1933 by the Lord Lieutenant of Staffordshire, John Ryder, 5th Earl of Harrowby.

In 2004 the hospital was closed and the services transferred to the Samuel Johnson Community Hospital at Greenhill. The old hospital site became a small housing development. There is a plaque at the entrance to the estate detailing its former use, and the road that accesses the estate is called Mary Slater Road, after the benefactor whose generosity helped build the original nursing home.

The former Victoria Hospital stood on this site and was opened in 1933 as a voluntary hospital funded by public subscription and local benefactors. It remained a source of pride to the community until it was replaced by the Samuel Johnson Community Hospital in 2007

Site of the former Victoria Hospital, The Friary.

W

Edward Wightman

The last man to be burned at the stake in England for heresy was Edward Wightman. Wightman was from Burton upon Trent and was, like George Fox, a religious dissenter. He made various extreme remarks, claiming that there was no Son of God, that he was himself the Son of God, and that anyone could be the Son of God. Such controversial remarks were considered unacceptable in the seventeenth century and he made himself even more unpopular when he presented the monarch, King James I, with a document outlining his views. The king was horrified by this and demanded that Wightman should be brought to account. He was interrogated in March 1612 by

Lichfield Market Square.

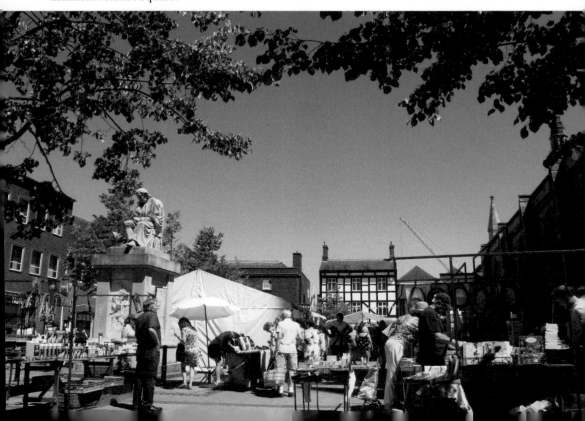

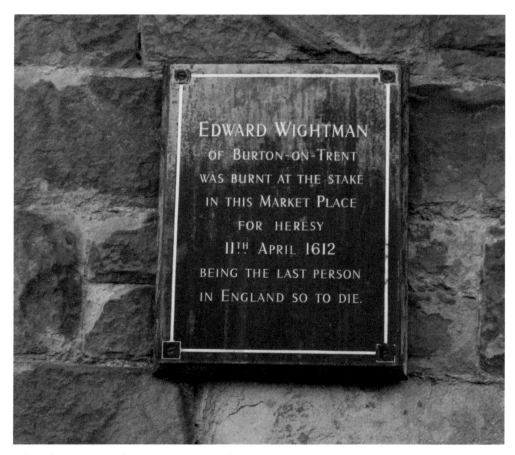

Edward Wightman plaque on St Mary's Church.

the bishop of Lichfield and the bishop of Westminster, two of the most important men in the country, and was sentenced to death by burning at the stake. It is not known exactly where the burning took place but it is believed to be somewhere on the Market Square. A large crowd gathered to witness the spectacle and, as the fires were lit around his legs, Wightman cried out to them repeatedly. The good people of Lichfield believed that he was recanting and denying his claims. They decided to have mercy upon him, and rescued him from the stake by beating out the flames with their hands. It is said that some of them burned the skin from the palms of their hands as they did so. Wightman was saved but, just a few weeks later, he repeated his outrageous claims and was sentenced to death yet again. This time, on 11 April 1612, the Sheriff of Lichfield built the stake up with extra wood and kindling, so that the flames would be even greater. Once again Wightman called out in distress as the flames swept over his legs but this time the good people of Lichfield, having had their fingers burned before, declined to rescue him. He was the last man in the country to be burned at the stake for the crime of heresy, although the burning of women convicted of witchcraft continued.

Wulfhere of Mercia

Wulfhere was the king of Mercia from AD 658 to 675 and was the most powerful king of southern Britain. In 669 Wulfhere gave land at Lichfield to Chad to establish a religious settlement and spread the word of Christianity in the kingdom of Mercia. It is not known exactly why Lichfield was chosen but its central location may have influenced its selection. Lichfield lies close to the intersection of two Roman roads: Ryknild Street (now the A38), linking it to Burton upon Trent and Derby; and Watling Street (now the A5), leading to the Anglo-Saxon town of Tamworth. The bones of King Wulfhere are reputed to have been buried at Lichfield Cathedral, although there is no direct evidence to support this. A statue of Wulfhere stands on the west front of Lichfield Cathedral, alongside St Chad.

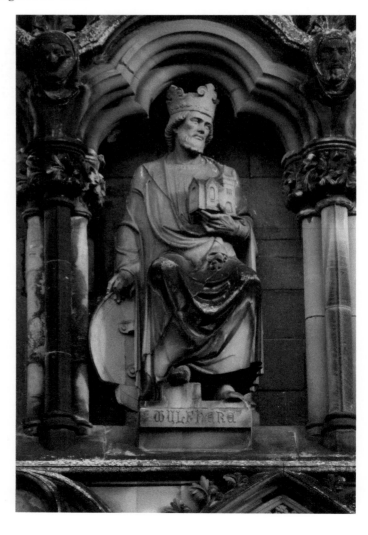

King Wulfhere statue on Lichfield Cathedral.

Edward Sydney Woods

Bishop of Lichfield is one of the most significant appointments in the English Church, and they have often been friends of the monarchy. This was definitely true of Edward Sydney Woods, who was appointed 94th bishop of Lichfield in 1937 and served throughout the Second World War. Woods was a friend of King George VI and Queen Elizabeth and it was said that every member of the royal family at that time had visited the Cathedral Close as a guest of the bishop.

Edward was born on 1 November 1877 and his mother, Alice Fry, was the granddaughter of the prison reformer Elizabeth Fry. He went on to become the chaplain, and later the vicar, of Holy Trinity, Cambridge. While there he befriended Harold Abrahams who later found fame as a runner at the 1924 Olympics and whose role was featured in the film *Chariots of Fire* – the two men remained lifelong friends. Woods was a vicar, chaplain, archdeacon and finally suffragan bishop of Guildford in Surrey before being appointed bishop of Lichfield. He was a tall man, at over 6 feet, with an engaging and easy-going manner, and was not comfortable with being addressed as My Lord. When he met his vergers at Lichfield for the first time he strode towards them, struck out his hand and said 'Good morning chaps!'. This was perhaps not what the vergers would have expected from a bishop, being used to a more serious greeting from previous incumbents.

The diocese of Lichfield was, and still is today, very large and Bishop Woods took to driving round to the various parishes under his control in a rather battered old car with a very high mileage on the clock. Eventually the workers at a local company he used to visit decided to club together and offer to buy him a new car so that he would be able to stay on the road. He frequently travelled abroad, visiting Malta, Singapore, New Zealand and Africa, where he went big-game hunting. In 1944, when visiting the British troops in Italy, he went to the Vatican and had an audience with the Pope. This is believed to be the first private meeting between an Anglican priest and a pontiff.

In another incident, Woods was due to travel to Stafford to open an art exhibition at the library. The intention was that a driver would drop him at the library and then return afterwards to take him back to Lichfield. Unfortunately, Woods instructed the driver to drop him at the Art School before realising he had got the wrong location. He was thus left facing a long walk to the library. The attendees at the exhibition were very surprised, and no doubt amused, to see the bishop of Lichfield in his mitre, gown and carrying his crozier, arriving at the library on the back of a milk float! To avoid being late for the opening, Woods had been forced to thumb a lift from the first vehicle to stop!

Woods was a very fine orator and, during the 1940s, a regular contributor to the BBC's religious radio programmes. His talks attracted a large number of listeners and on one occasion he was told his audience was expected to exceed 6 million

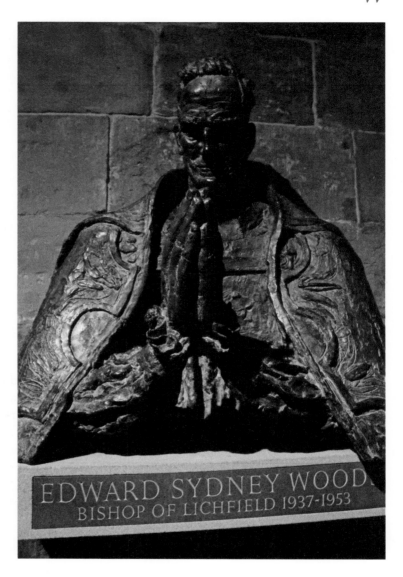

Bishop Edward
Woods sculpture
by Jacob Epstein,
Lichfield Cathedral.

people. Sadly, the technical department had to inform him afterwards that there had been a fault with the transmission – his sermon had been heard only by the staff in the studio!

Bishop Woods died on 11 January 1953 from an attack of bronchitis, while still in post. In April 1989 the Queen Mother, who had been a personal friend, visited Lichfield Cathedral to unveil a statue of Bishop Woods by the American sculptor Jacob Epstein, which is in the vestibule of the Chapter House.

X

X-ray Funds

In the 1930s and 1940s funds were raised for an X-ray machine at the Victoria Hospital and Nursing Home, which was close to the Friary roundabout. In the days before the National Health Service it was essential that new machinery and equipment were purchased, and local residents made contributions to the fund.

The 'X-ray Car'

In 1939, Kennings garage on St John Street displayed what was called the 'X-ray car'. A Vauxhall saloon car had been cut into sections so that every element of it could be viewed. The car had previously been on display in London at Earl's Court.

Y

Lichfield Youth Hostel Association

In April 1937 the first Lichfield Youth Hostel Association was formed, with headquarters in the Common Room on Dam Street. Hostels were proving to be very popular at this time, springing up all over the country and frequented by walkers and cyclists. The Lichfield hostel provided the only break in the hostel chain between Warwick and the Peak District. It opened with an initial ten beds for travellers and by 1939 it had provided over 1,600 bed-nights to hostellers from all over Britain and Europe.

Yeomanry House

Yeomanry House was built around 1730 to provide accommodation for members of the Staffordshire Yeomanry. The house was at the top of St John Street, opposite St John's Hospital. At the end of the nineteenth century the yeomanry moved out and the building stood empty until 1898 when the Lichfield High School for Girls took possession. The girls' school had been established at No. 15 on Market Street but, due to the success of the school, the house became too small and they moved into larger premises. The first head teacher, Miss Marion Hawkins, developed and expanded the school, and took in boarders as well as day pupils. Although primarily a girls' school, the nursery school accepted young boys as well. It seems that there may have been a ghost in the building, as the young girls who boarded at the school used to claim that they heard the sound of a crying baby that disturbed their sleep every night. Every morning at breakfast the girls would ask to see the baby, despite the fact that Miss Hawkins told them that there was none in the building. However this story persisted and eventually Miss Hawkins decided to investigate. Looking back in the records she found that an army officer had lived at Yeomanry House with his wife and a baby that used to cry every night. Eventually the baby's nanny had become so frustrated and angry at the household being woken up every night that she picked up the baby and shook it so hard that

she shook it to death. Was this the baby that the young school girls could hear crying every night?

By 1920 the school had become so successful that larger premises were needed yet again, and it moved to the old Friary building. Yeomanry House remained empty until the 1930s when it was demolished and a garage was built on the site. Several garages were located on the same site, including Kennings and Tempest Ford, but the site was cleared in 2018 and is currently empty, awaiting development.

Zeppelins

In the First World War the bishop of Lichfield, the Right Revd John Kempthorne, warned of the dangers of Zeppelin airships bombings in Britain. Several Zeppelin crews that were killed when their airships were shot down or crashed are buried at the German War Graves at Cannock Chase, a short distance from Lichfield.

Zoonomia

Erasmus Darwin, a physician who was the grandfather of Charles Darwin, lived on Beacon Street in Lichfield, a short distance from Lichfield Cathedral. Erasmus became interested in the functioning of the body and wrote a two-volume book called *Zoonomia; or the Laws of Organic Life* about the workings of the human body, dealing

Zoonomia by Erasmus Darwin. (Photo: Erasmus Darwin House)

Left: Erasmus Darwin wall sculpture at Erasmus Darwin House.

Below: Erasmus Darwin House and Lichfield Cathedral.

with pathology, anatomy, psychology, and the functioning of the body. The first volume was published in 1794 with the second volume appearing in 1796. It outlined some of his views on the initial workings of evolution and it was these works that Charles Darwin developed and enhanced to produce his Theory of Evolution.

Zachary Turnpenny

Zachary Turnpenny, born *c.* 1600, was a senior bailiff of Lichfield in 1658 – a role that later became known as Sheriff of Lichfield. Zachary was married twice, firstly to Ann, whose family name is not known, and then to Margaret Smyth in 1654. In 1656 he failed to attend St George's Court in the Guildhall, where he was one of the petty constables or dozeners, and was fined 2 shillings and 6 pence for his non-appearance. He contributed to the poor of Lichfield through Turnpenny's Charity, which provided bread for the poor of Beacon Street. The charity was still handing out bread rolls to the poor on Ascension Day in the 1930s and later became amalgamated into the Michael Lowe's and Associated Charities group in 1980.

Apolline Zuingle

One of the most unusual and flamboyant of Lichfield's business owners was Apolline Zuingle, a French dance instructor who had taught in Paris, Berlin and Germany, as

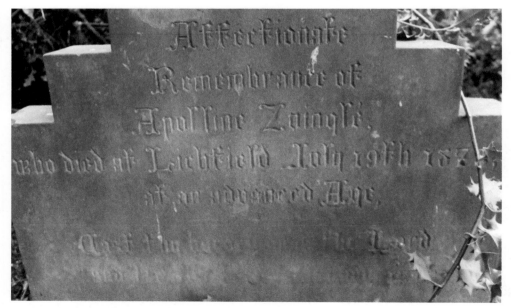

Gravestone of Apolline Zuingle, St Michael's Churchyard.

Brooke House.

well as in Scotland. By 1856 she was operating classes in Dam Street at Brooke House, where Lord Robert Greville Brooke had been shot and killed by John Dyott during the English Civil War.

Apolline ran a number of classes, not only in Lichfield but also across the Midlands including Stafford and Walsall. She was injured in a railway accident at Dudley, in the West Midlands, in November 1867 and wrote to the railway line responsible, the London and North-Western Railway, to claim expenses for injuries that had adversely affected her dance classes. It appears that no settlement was ever made to her though. She died in Lichfield in 1871 and is buried in the graveyard at St Michael's Church on Greenhill.

Bibliography

Bird, Jean, *Hyacinths and Haricot Beans; Friary School Memories 1892–1992* (Lichfield, 1995)

Brown, Cuthbert, *Born in a Cathedral City* (Bloomfield and Son: Stratford-Upon-Avon, 1988)

Coley, Neil, *Lichfield Pubs* (Amberley Publishing, 2016)

Gresley, William, *The Siege of Lichfield* (FB&c Ltd: London, 2015)

Mullins, Helen, *The History of The Friary School Lichfield* (Benhill Press Ltd: Rugeley, 1981)

Shaw, John, *The Old Pubs of Lichfield* (Lichfield, 2001)

Stone, Janet, *Edward Sydney Woods, 94th Bishop of Lichfield* (Victor Gollance: London, 1954)

Websites
The British Newspaper Archive
www.workhouses.org.uk
Lichfield Lore
British History Online
Family Tree Forum Magazine

Acknowledgements

The author would like to thank Lichfield City Council and the Samuel Johnson Birthplace Museum for their help and support and use of photographs and to thank Erasmus Darwin House for the use of their photographs. All other photographs are the property of the author. The author would also like to thank Joss Musgrove-Knibb for her help, guidance and support and also thank his fellow High Constable of Lichfield 2018–19, Jack Crawford, for his invaluable assistance.

About the Author

Jono is a tour guide and local historian and lives in Lichfield. He worked for over ten years as a tourism officer for Visit Lichfield, the tourism department at Lichfield District Council. Jono writes for a local Lichfield magazine and also writes website and social media reviews about plays and musicals including those at the Lichfield Garrick Theatre.